AMAZING BUTTERFLIES COLORING BOOK

OVER 40 DELIGHTFUL
PICTURES WITH FULL
COLORING GUIDES

SIRIUS

SIRIUS

This edition published in 2024 by Sirius Publishing, a division of
Arcturus Publishing Limited,
26/27 Bickels Yard, 151–153 Bermondsey Street,
London SE1 3HA

978-1-3988-3638-9
CH011226NT
Supplier 29, Date 0424, PI00005886

Printed in China

Introduction

Who could fail to enjoy watching a butterfly flutter its way around a garden or park? It can almost always induce a feeling of calm as you watch how these delightful insects alight on a flower, stay for a few moments collecting nectar, and then delicately move on to the next. As natural historians can testify, over many centuries, they have proved endlessly fascinating.

Students of butterflies and moths are known as lepidopterists and this branch of entomology (the study of insects) arose after the Renaissance. From the early 17th century until around 1900, lepidopterology proliferated as explorers, accompanied by scientists, searched new parts of the world, and revealed the marvels of our natural world. Hundreds of specimens were brought back from such voyages for examination and many invaluable works were compiled, recording the new species of moths and butterflies that were discovered.

This coloring book contains a collection of images of butterflies and moths that has been selected from some of the most important works from the 18th and 19th centuries, including *The Aurelian: A Natural History of English Moths and Butterflies* by Moses Harris; *De Uitlandsche Kapellen voorkomende in de drie Waereld-Deelen Asia, Africa en America* by Pieter Cramer; *The Naturalist's Library, Vol. XXXI (Entomology, Foreign Butterflies)* by James Duncan and edited by Sir William Jardine; *Lepidoptera Exotica* by Arthur Gardiner Butler; *Genera des Lépidoptères: Histoire Naturelle des Papillons d'Europe et de Leurs Chenilles* by A. Depuiset; and *Surinaamische Vlinders* by I. Deel.

Illustrated by a variety of artists, the styles are always charming, and the overriding beauty of these winged creatures is there for all to see and enjoy. With more than 40 images to choose from, coloring enthusiasts can either follow the colors as shown in the original artworks or let their imagination take flight and devise their own unique color schemes as they complete the line artworks inside.

Key: *List of plates*

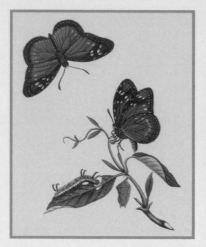

1 Queen *(Danaus Gilippus)*

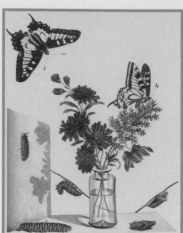

2 Swallowtail *(Papilionidae)*

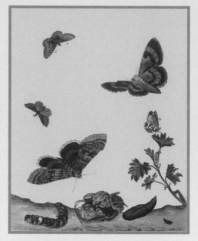

3 Small Pearl-Bordered Fritillary, Blue Underwing *(Boloria selene, Catocala fraxini)*

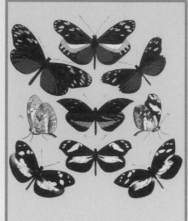

4 Butterflies of the family *Pieridae*

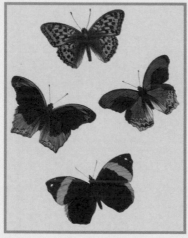

5 Butterflies of the family *Nymphalidae*

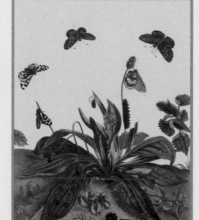

6 Glanville Fritillary, Tiger Moth *(Melitaea cinxia, Arctia caja)*

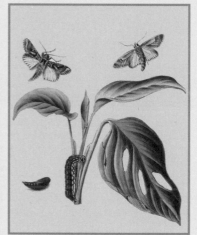

7 Sweetpotato Armyworm *(Spodoptera dolichos)*

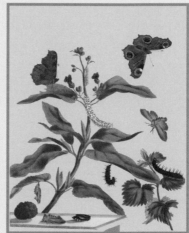

8 Peacock, Water Betony *(Saturnia pyri, Shargacucullia scrophulariae)*

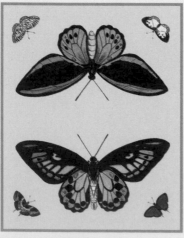

9 Green Birdwing *(Ornithoptera priamus)*

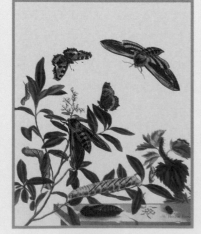

10 Privet Hawk, Tortoiseshell *(Sphinx ligustri, Nymphalis)*

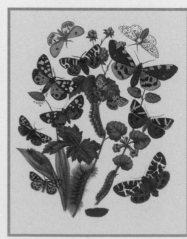

11 Moths of the family *Erebidae*

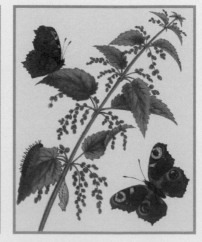

12 Peacock *(Aglais io)*

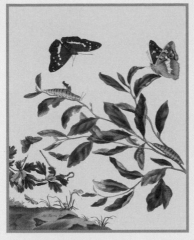

13 Purple Emperor, Green Hairstreak *(Apatura iris, Callophrys rubi)*

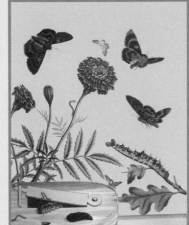

14 Lime Speck, Crimson Underwing *(Eupithecia centaureata, Catolcala Sponsa)*

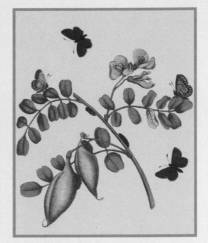

15 Glaucopis Cepheus *(Histioea cepheus)*

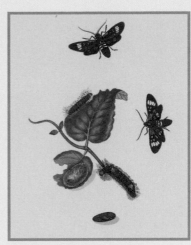

16 Butterflies of the family *Lycaenidae*

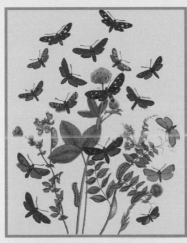

17 Moths of the family *Zygaenidae*

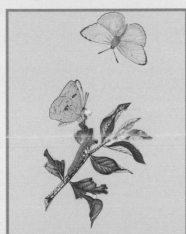

18 Cloudless Sulphur *(Phoebus sennae)*

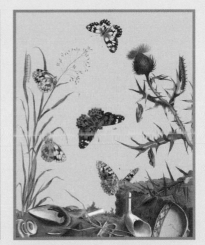

19 Painted Lady, Marbled White *(Vanessa cardui, Melanargia galathea)*

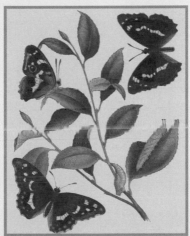

20 Purple Emperor *(Apatura iris)*

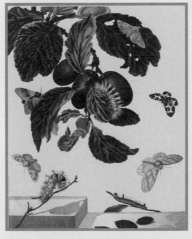

21 Yellow Tussock, Grey Dagger, Argent and Sable *(Dasychira basiflava, acronicta psi, Rheumaptera hastata)*

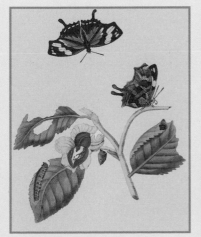

22 Tiger Leafwing *(Consul fabius)*

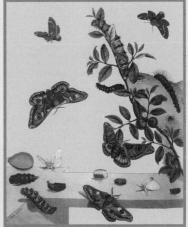

23 Emperor, Small Eggar, Yellow Tail *(Saturnia pavonia, Eriogaster lanestris, Euproctis similis)*

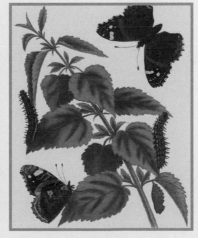

24 Red Admiral *(Vanessa atalanta)*

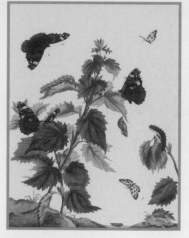

25 Red Admirable, Small
Magpie
*(Vanessa Atlanta,
Anania hortulata)*

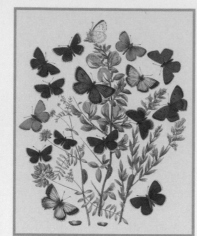

26 Butterflies of the
family *Lycaenidae*

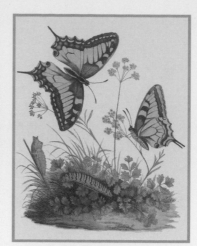

27 Old World
Swallowtail
(Papilio machaon)

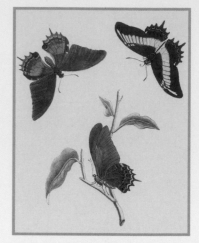

28 Swallowtail Varieties
(Papilionidae)

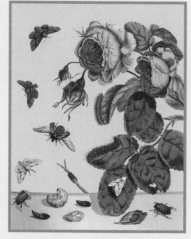

29 Lackey, White Ermine
*(Malacosoma neustria,
Spilosoma lubricpeda)*

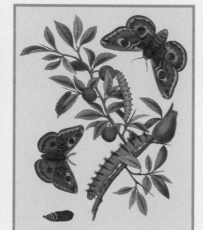

30 Emperor
(Saturnia pavonia)

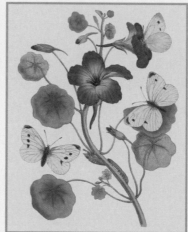

31 Green-veined White
(Pieris napi)

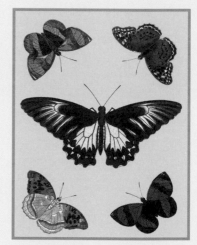

32 Butterflies of the
family *Nymphalidae*

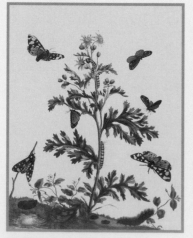

33 Pink Underwing,
Cream-spot Tiger
*(Phyllodes imperialis,
Arctia villica)*

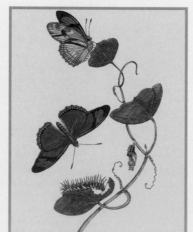

34 Julia
(Dryas iulia)

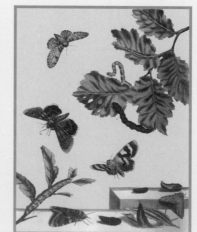

35 Peppered, Red
Underwing
*(Biston betularia,
Catocala nupta)*

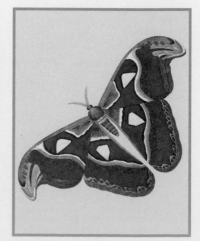

36 Atlas Moth
(Attacus atlas)

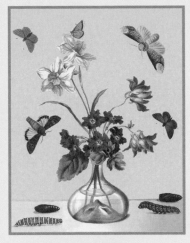
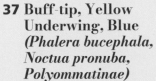

37 Buff-tip, Yellow
Underwing, Blue
*(Phalera bucephala,
Noctua pronuba,
Polyommatinae)*

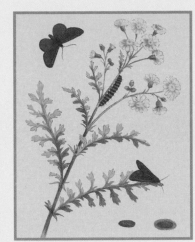

38 Cinnabar
(Tyria jacobaeae)

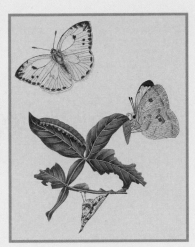

39 Apricot Sulphur
(Phoebis argante)

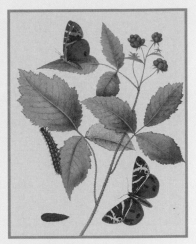

40 Jersey Tiger
*(Euplagia
quadripunctaria)*

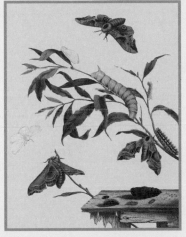

41 Eyed Hawk, White
Satin
*(Smerinthus ocellatus,
Leucoma Salicis)*

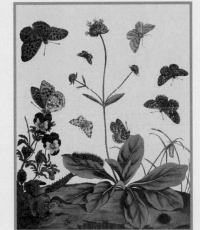

42 High Brown
Fritallaria, moths of
Geometridae family
(Fabriciana adippe)

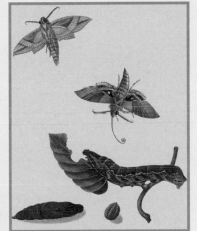

43 Gaudy Sphinx
(Eumorpha labruscae)

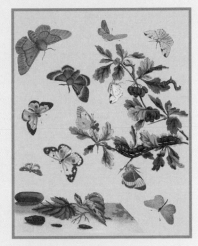

44 Great Eggar,
Brimstone, moths of
Pieridae family
*(Lasiocampa quercus,
Opisthograptis
luteolata)*

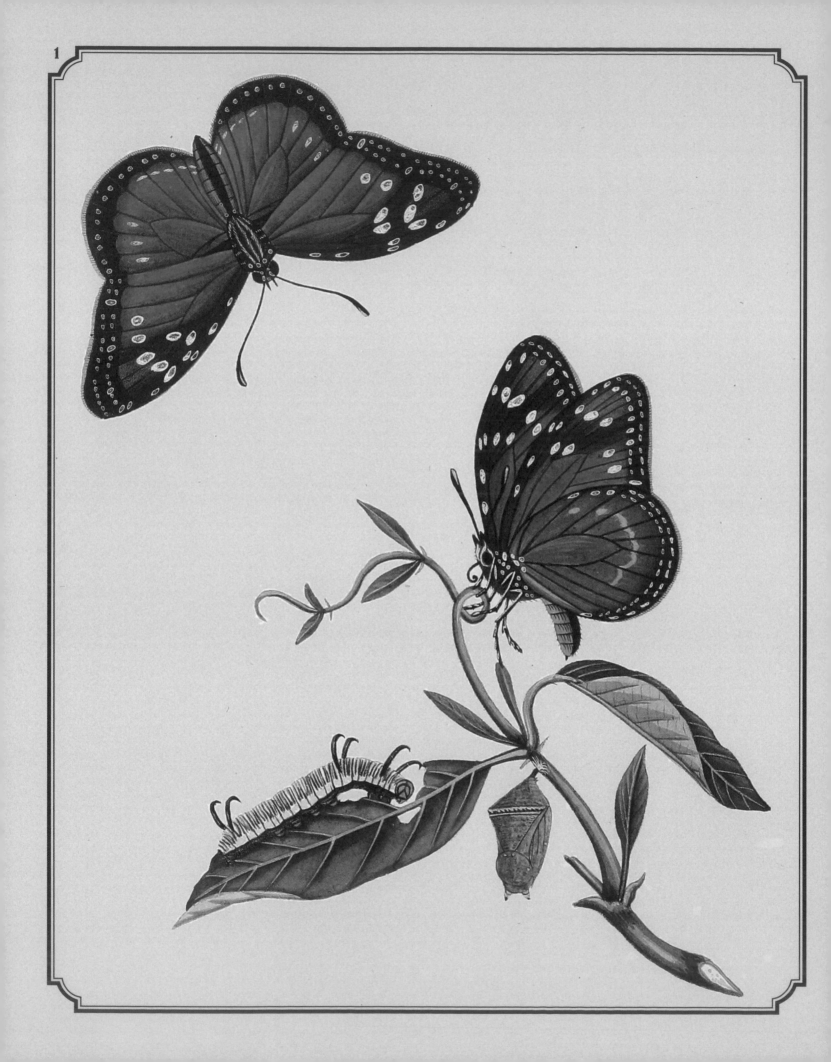

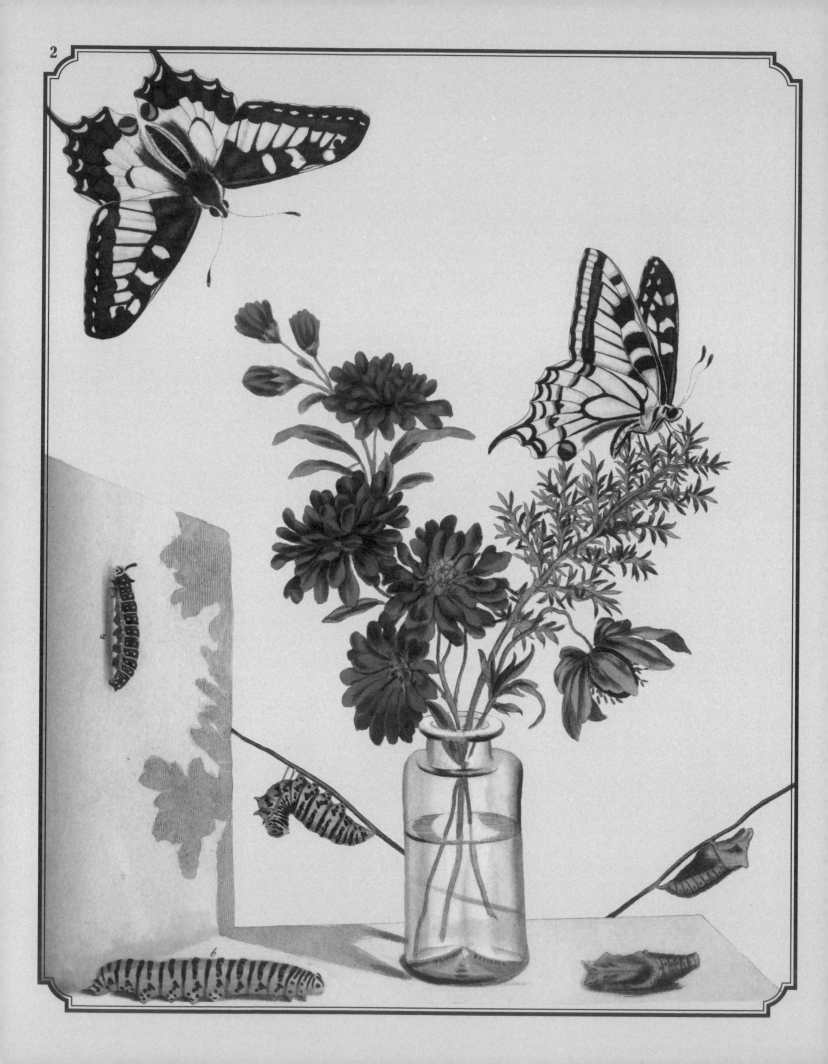

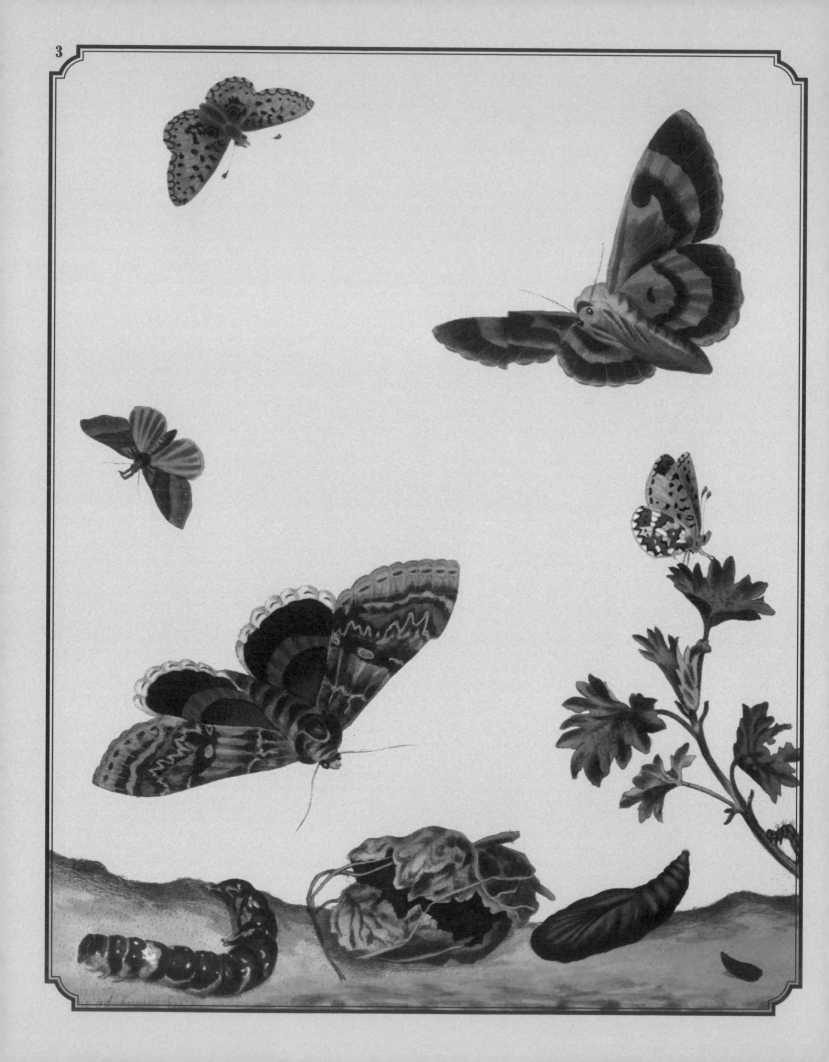

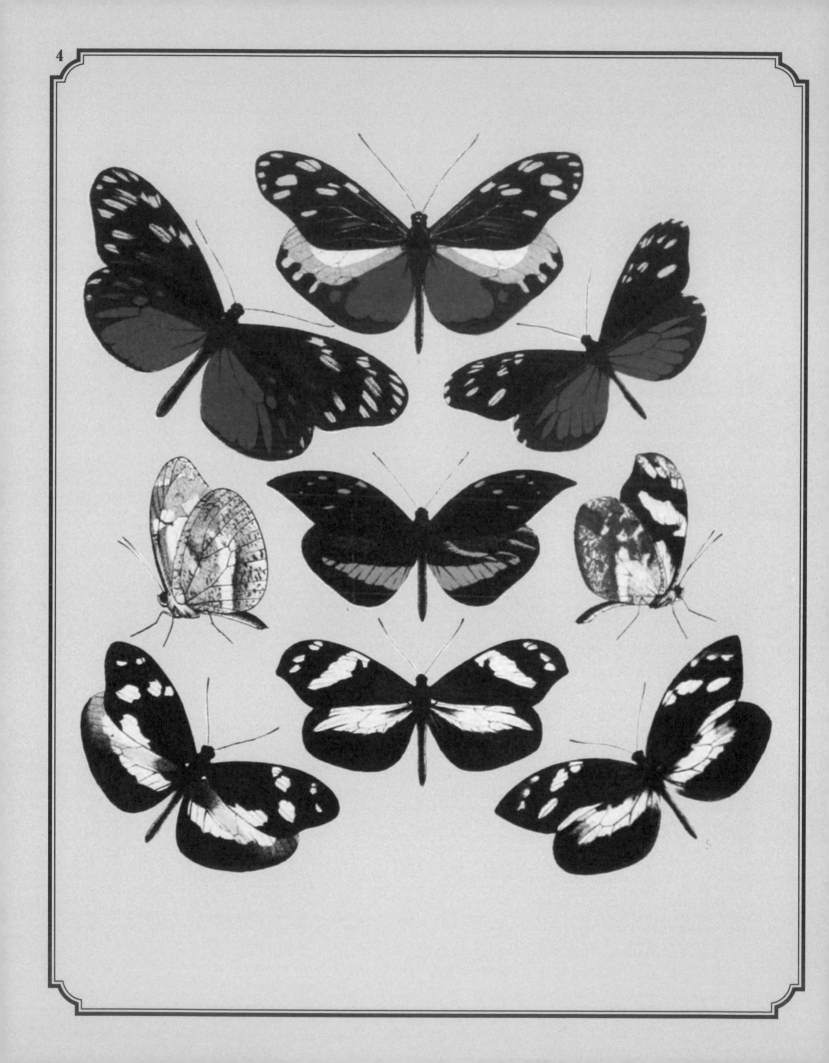

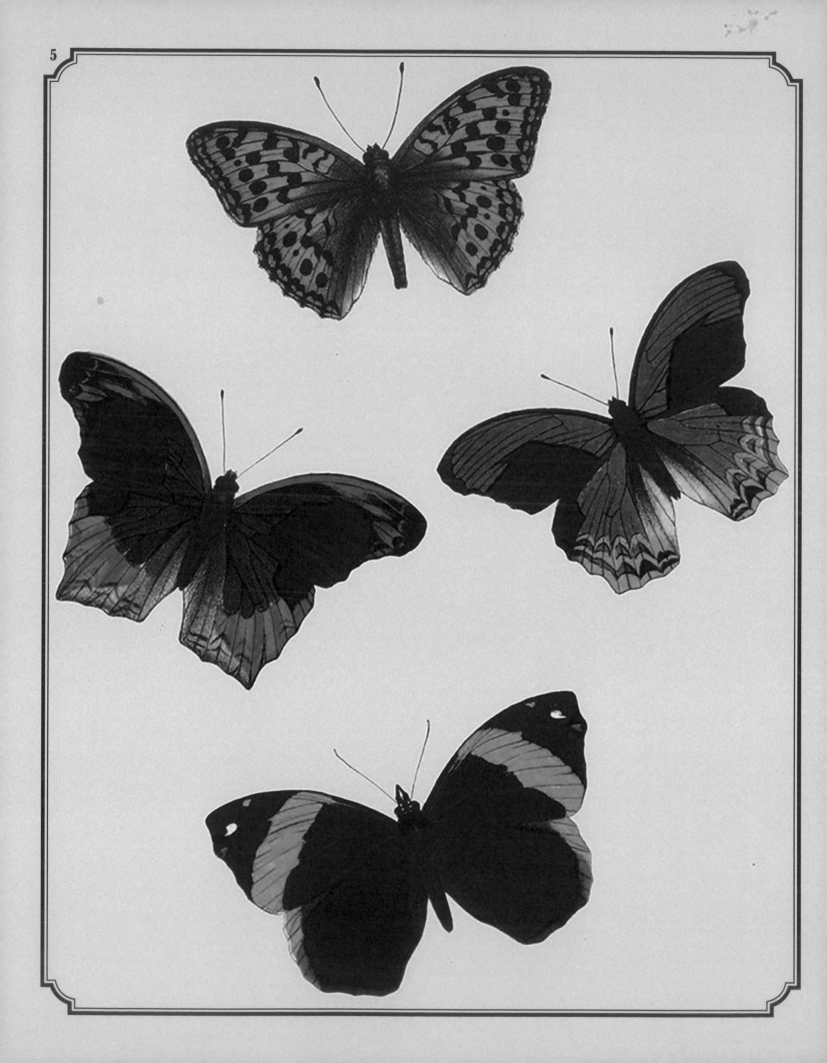

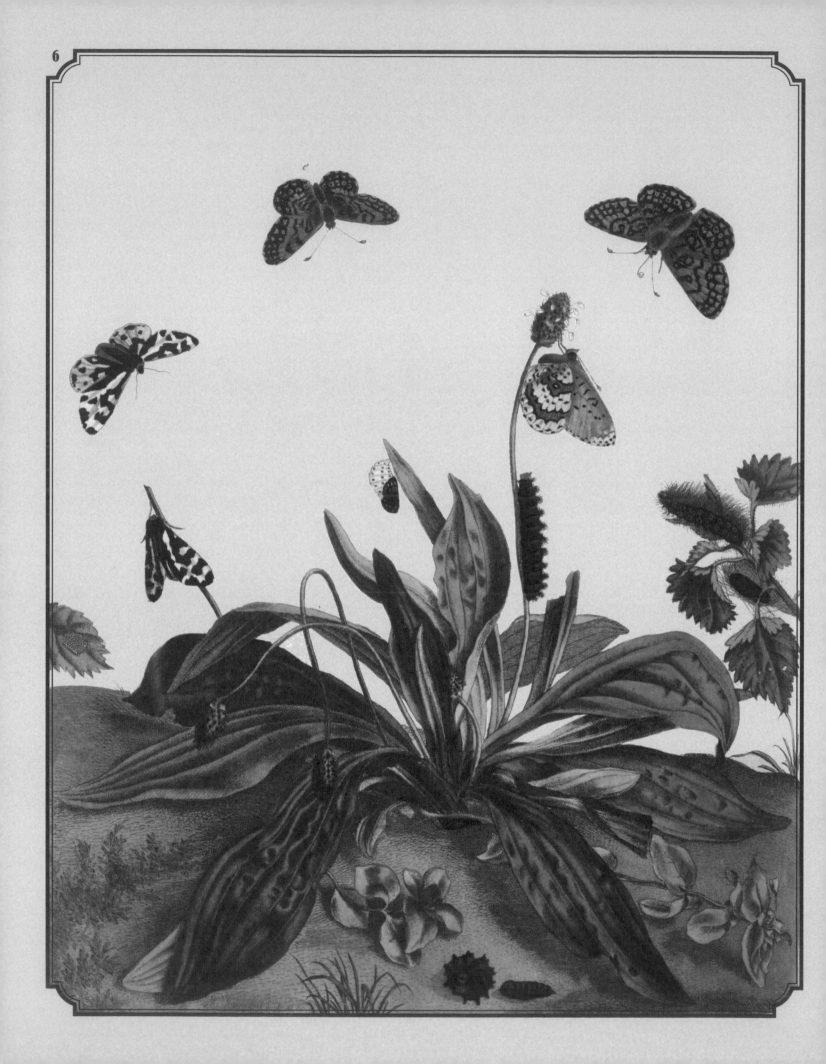

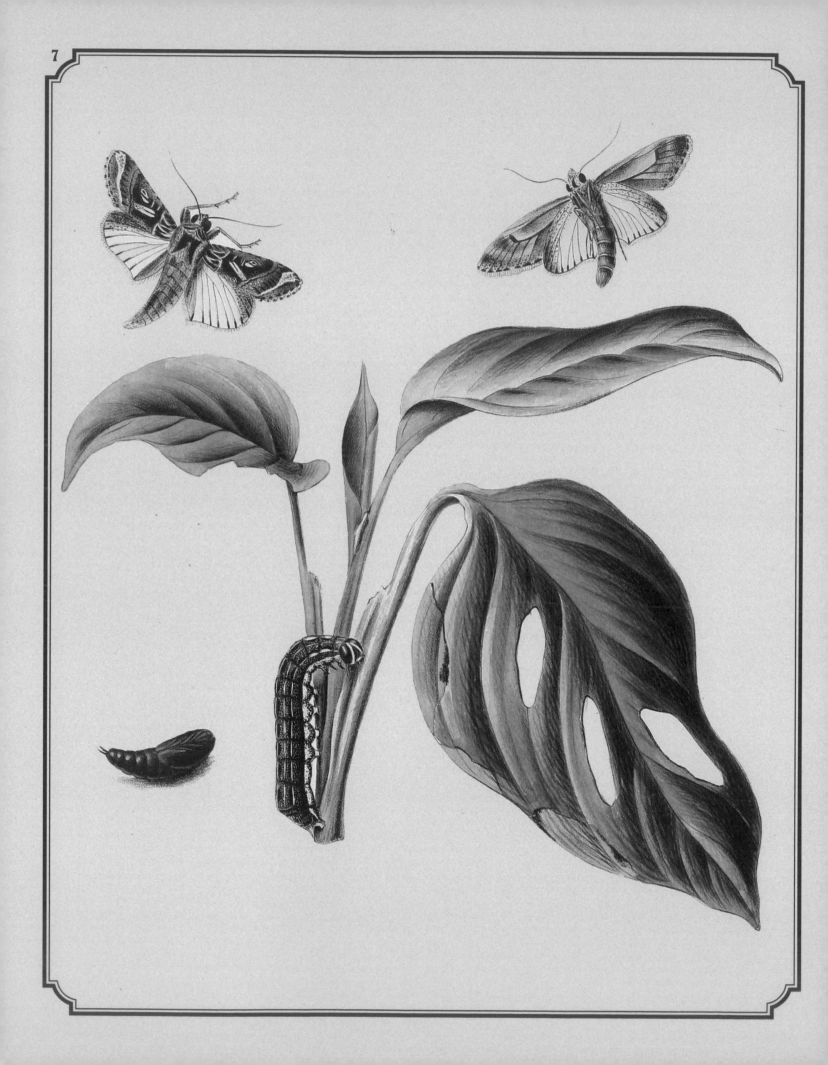

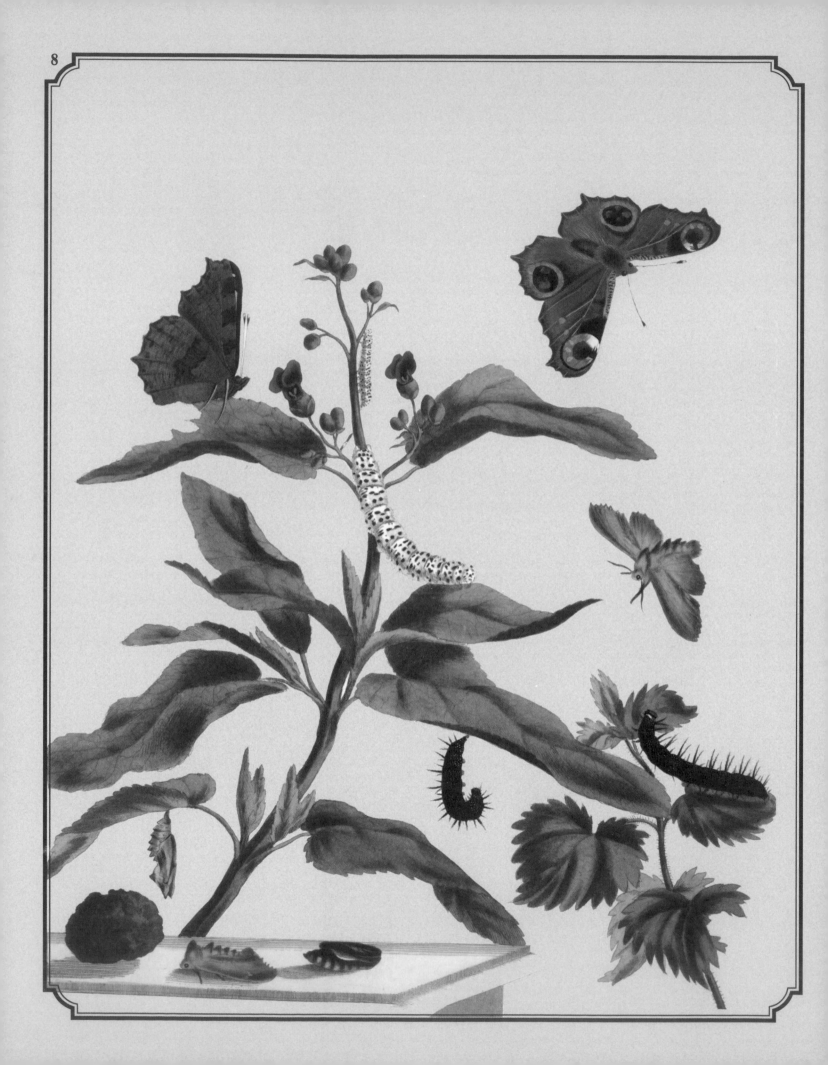

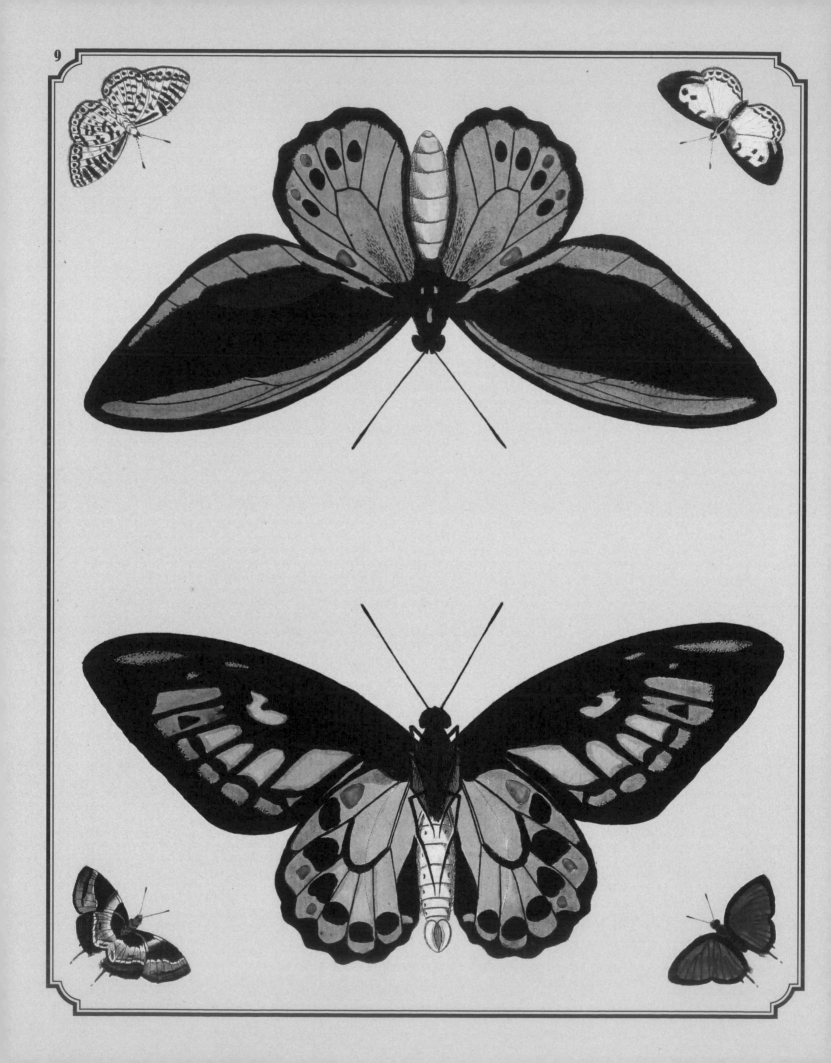

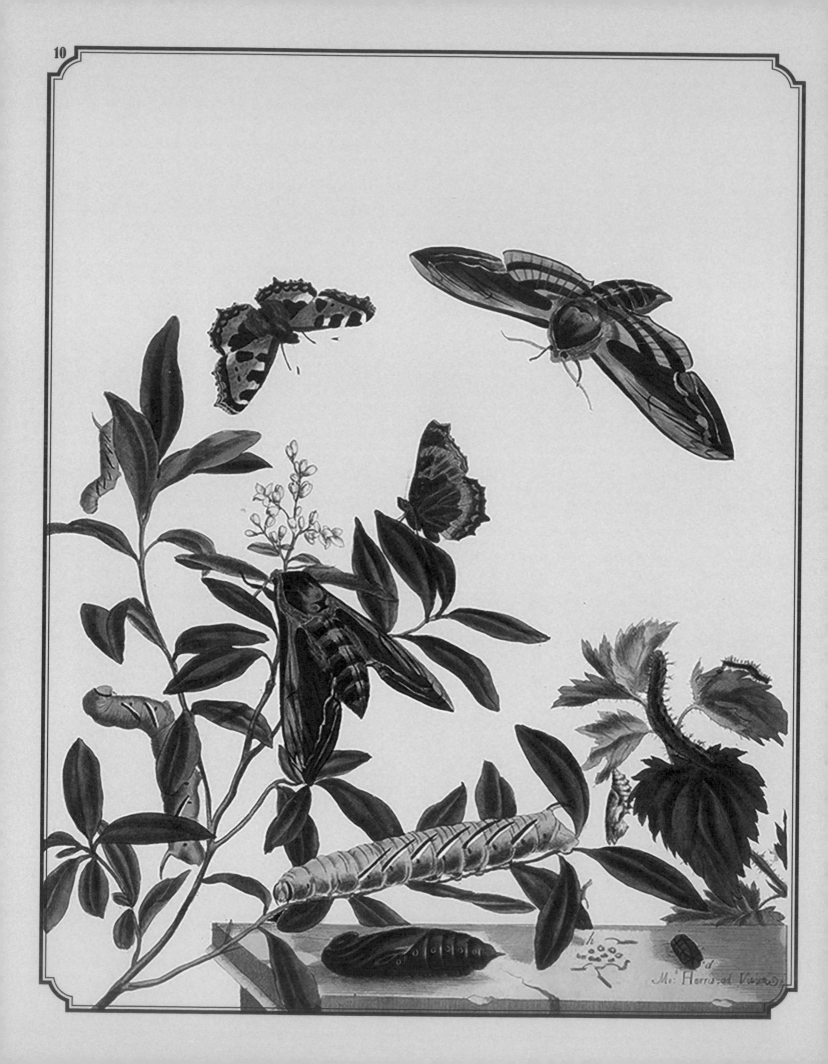

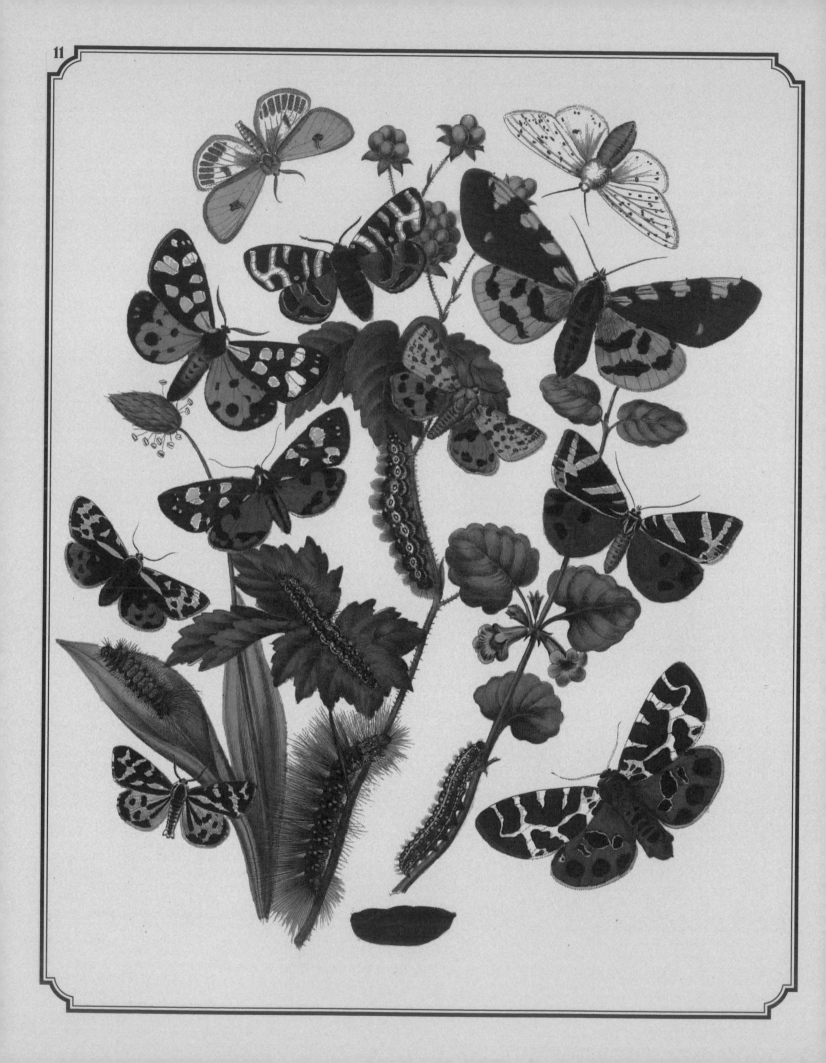

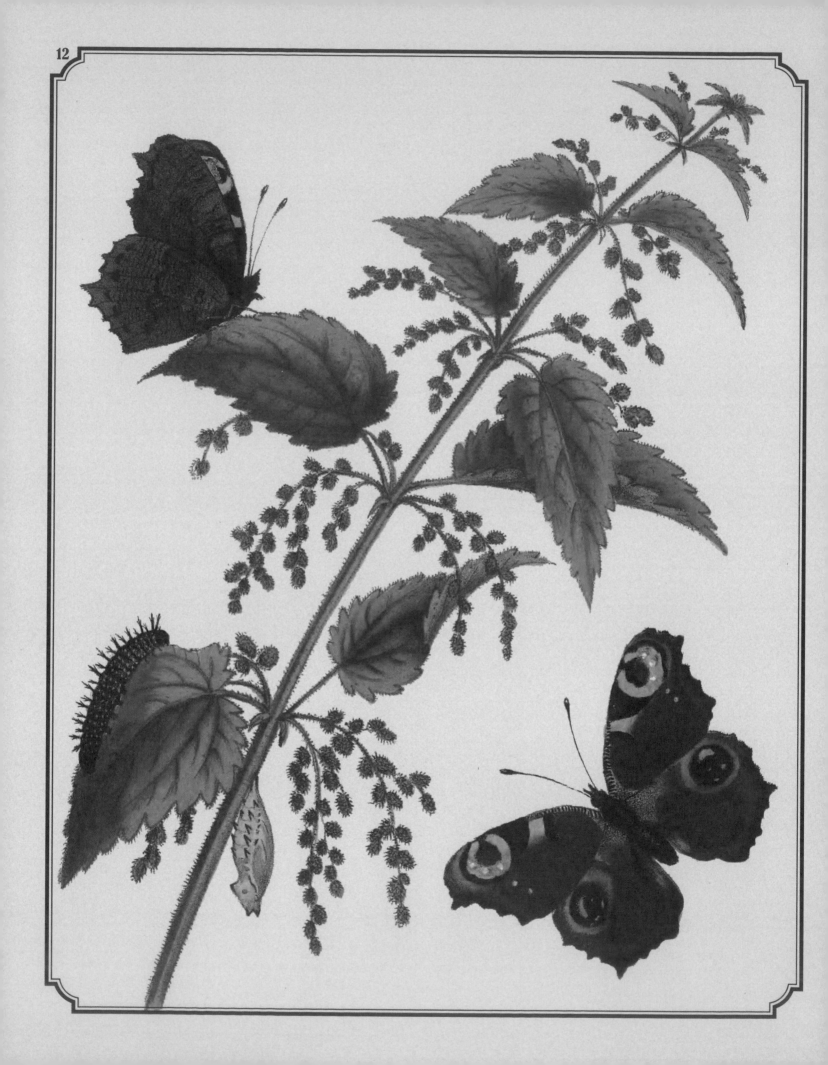

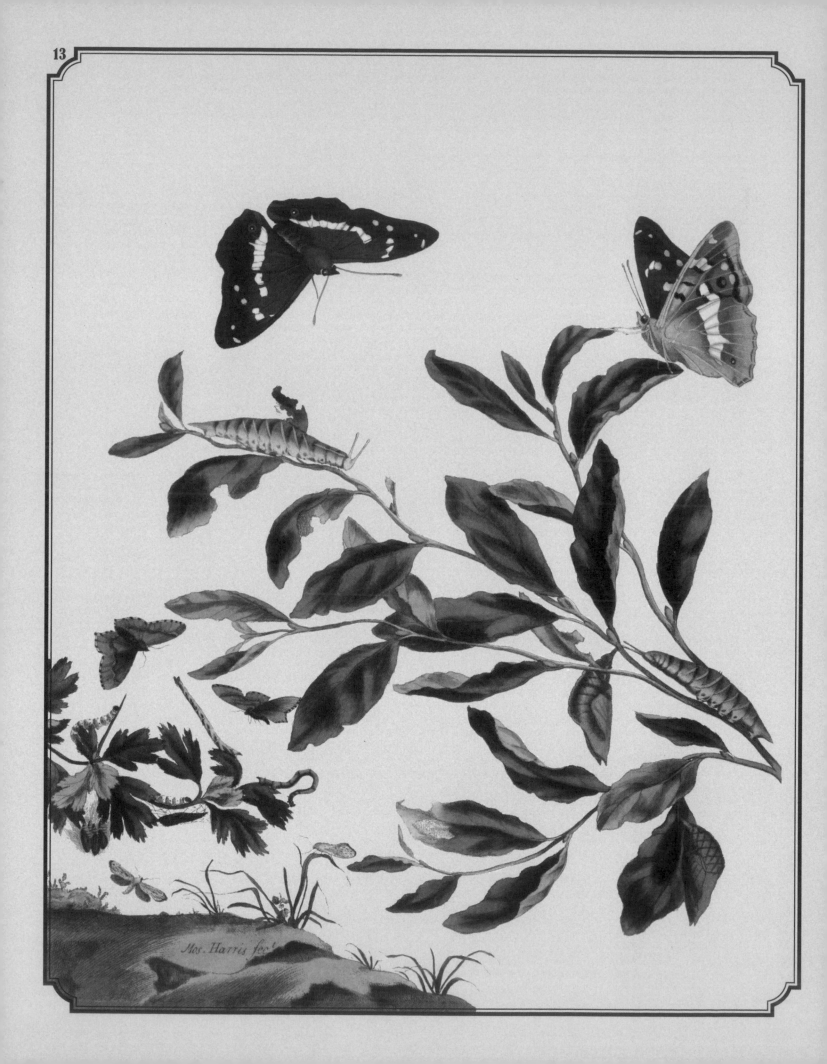

Mos. Harris fec.

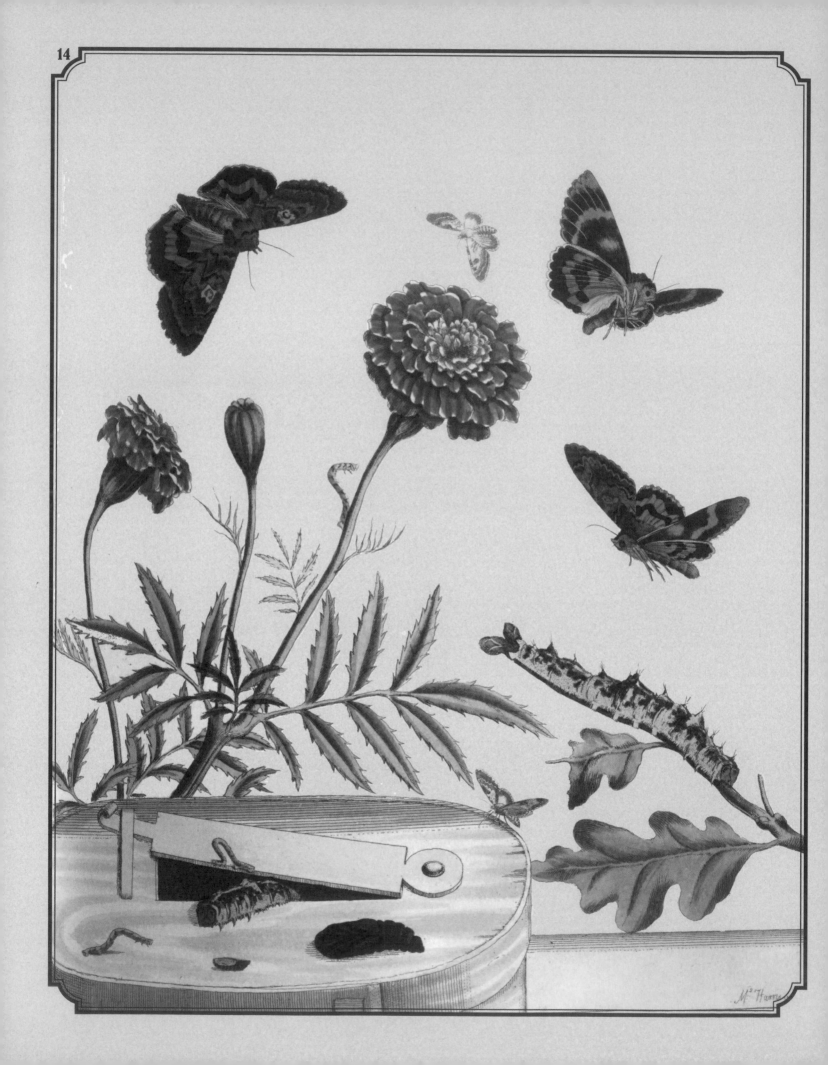

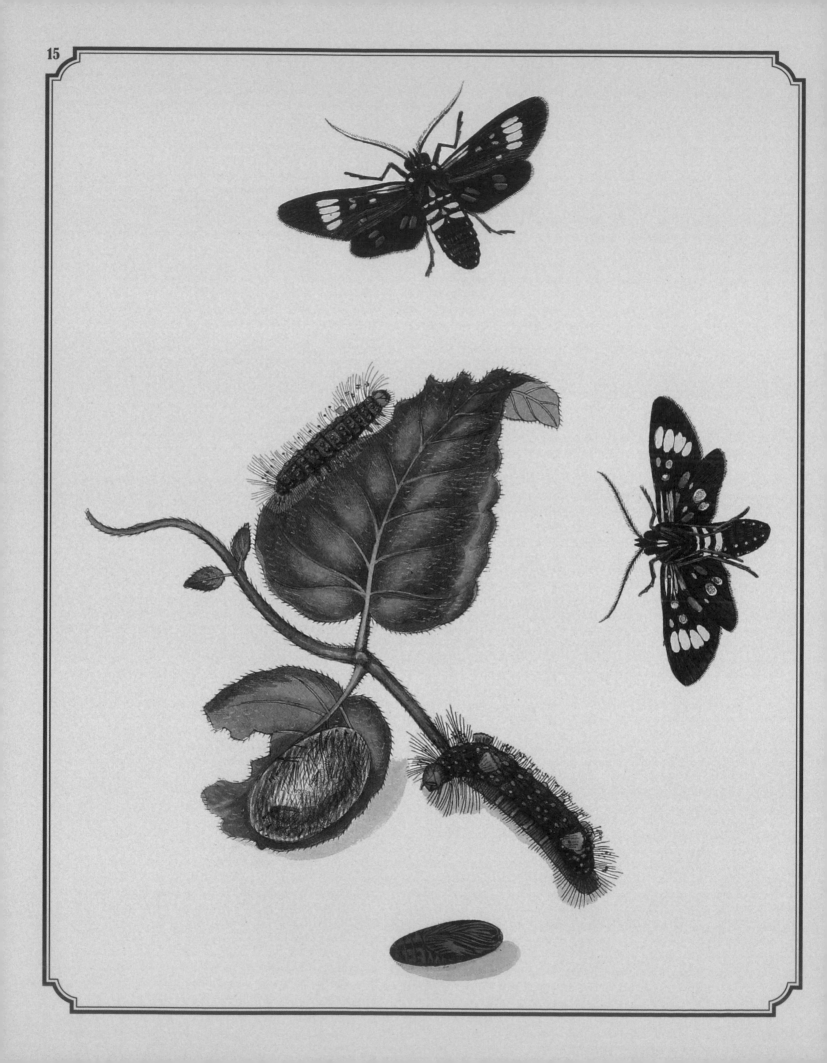

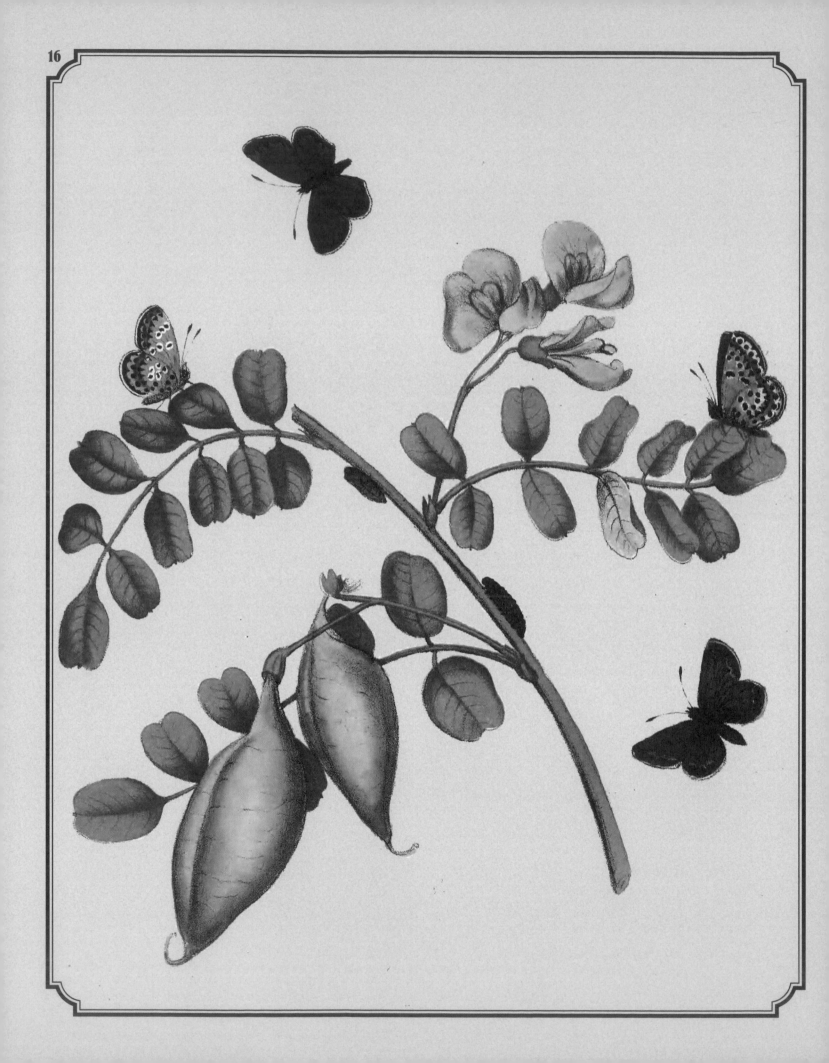

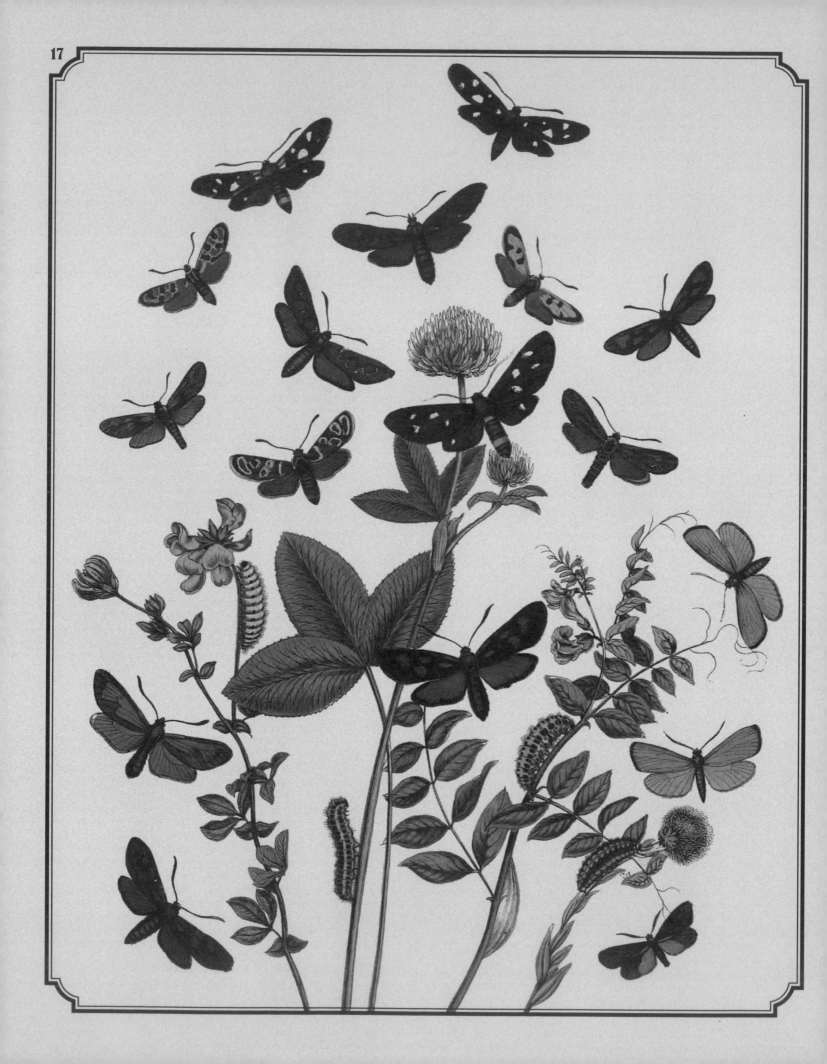

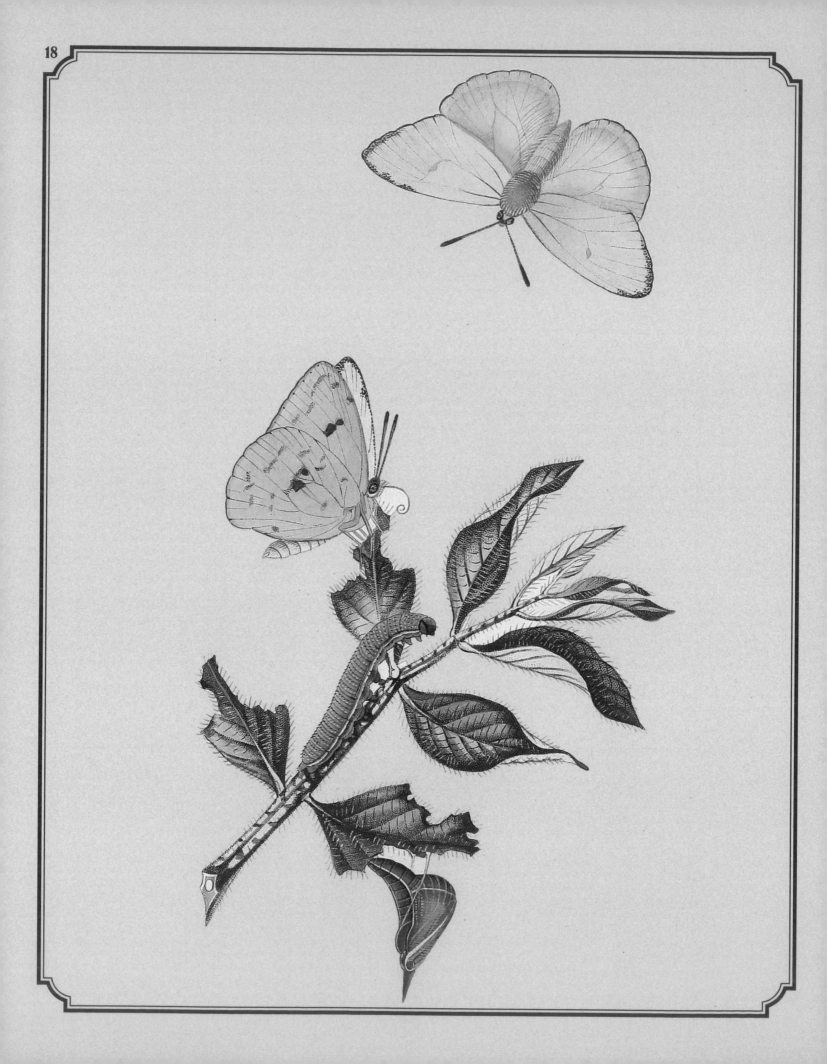

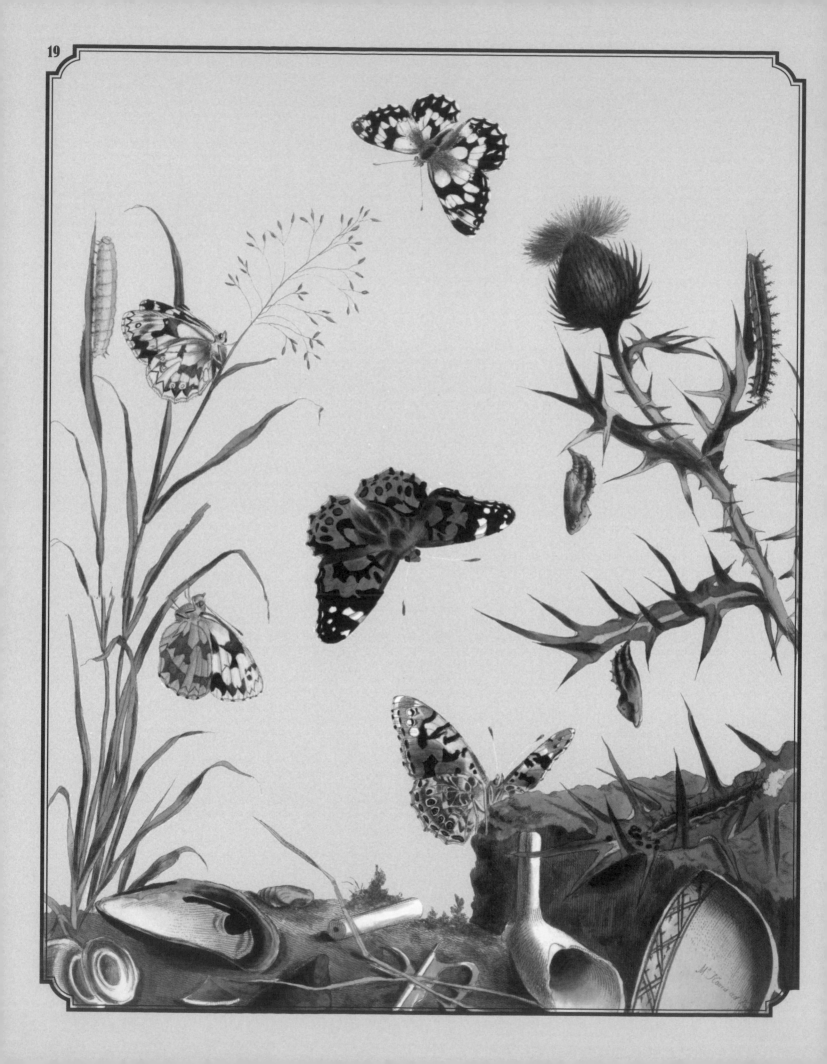

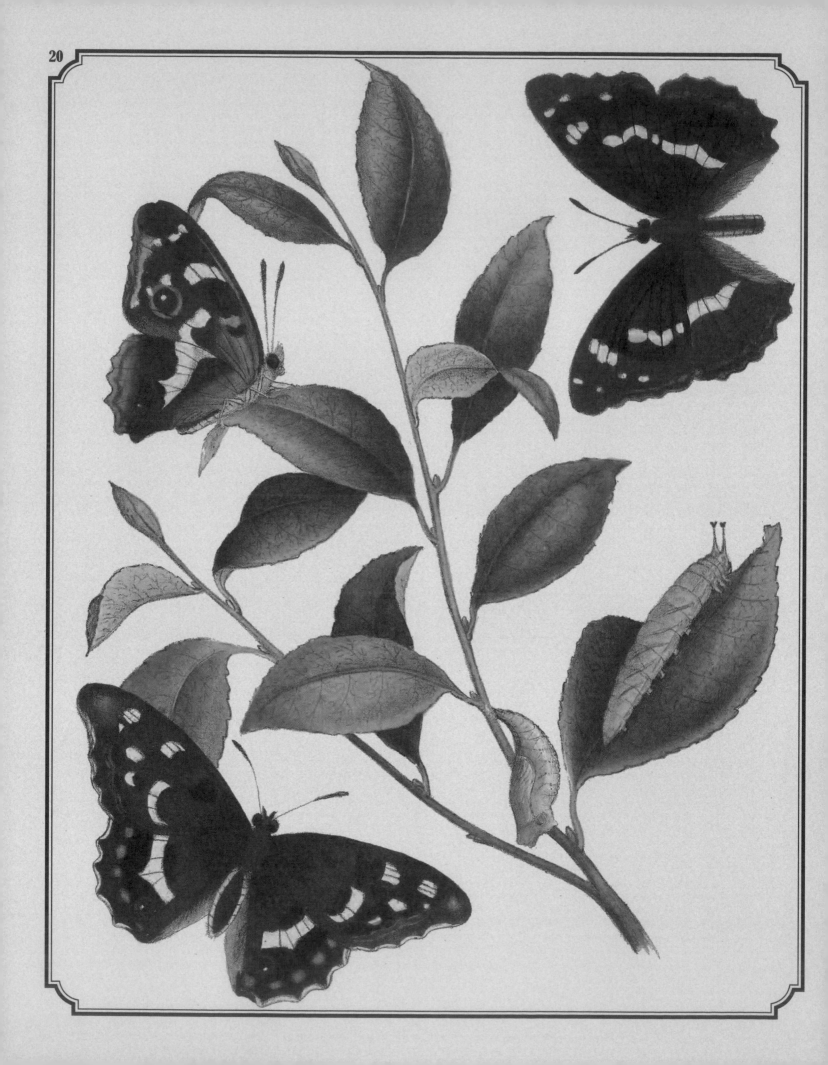

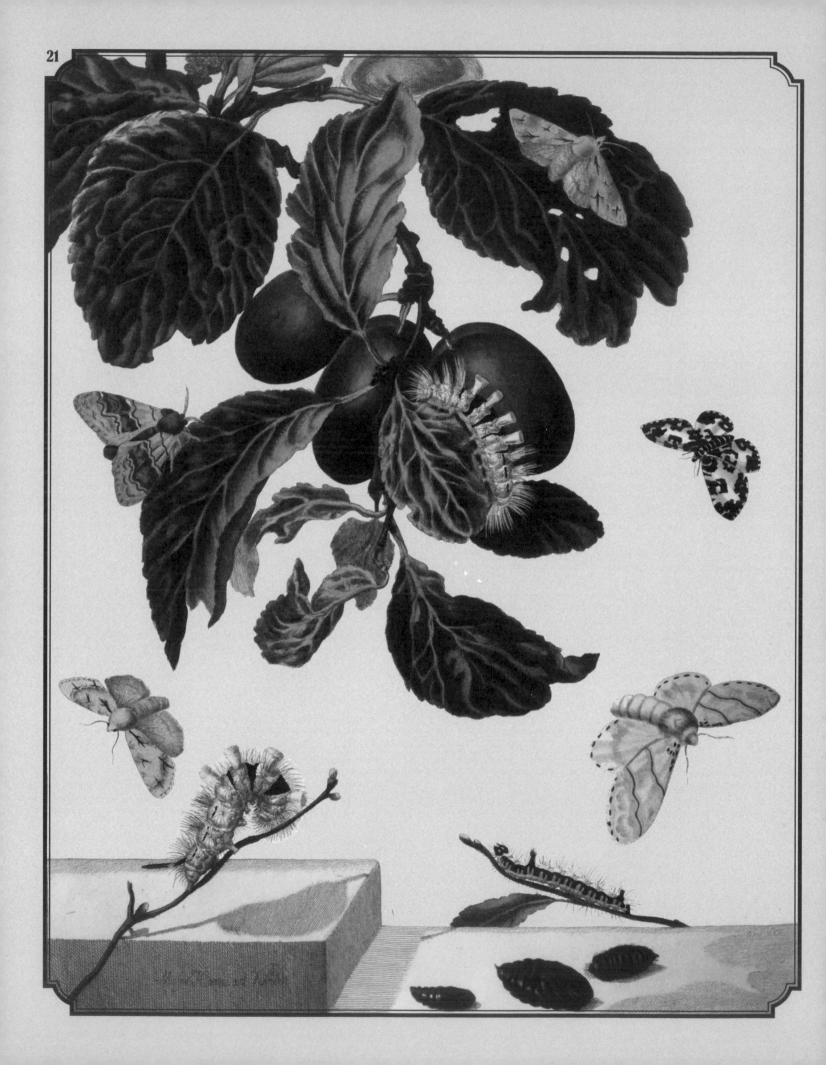

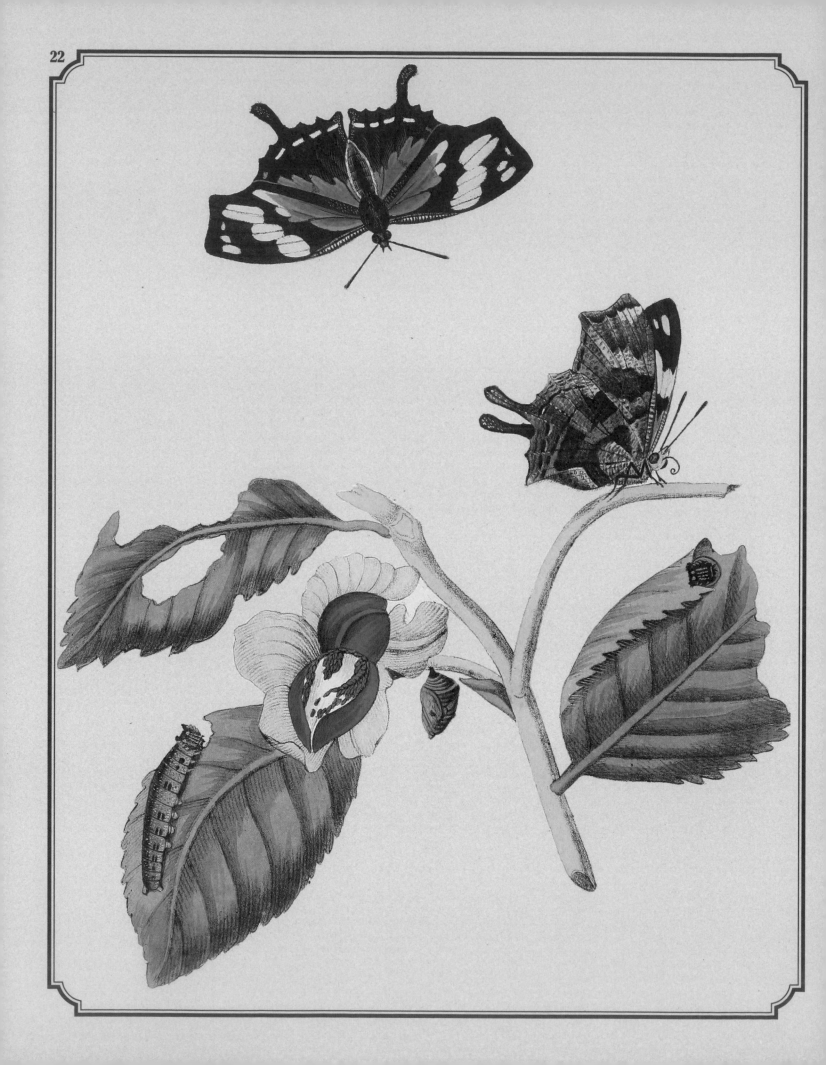

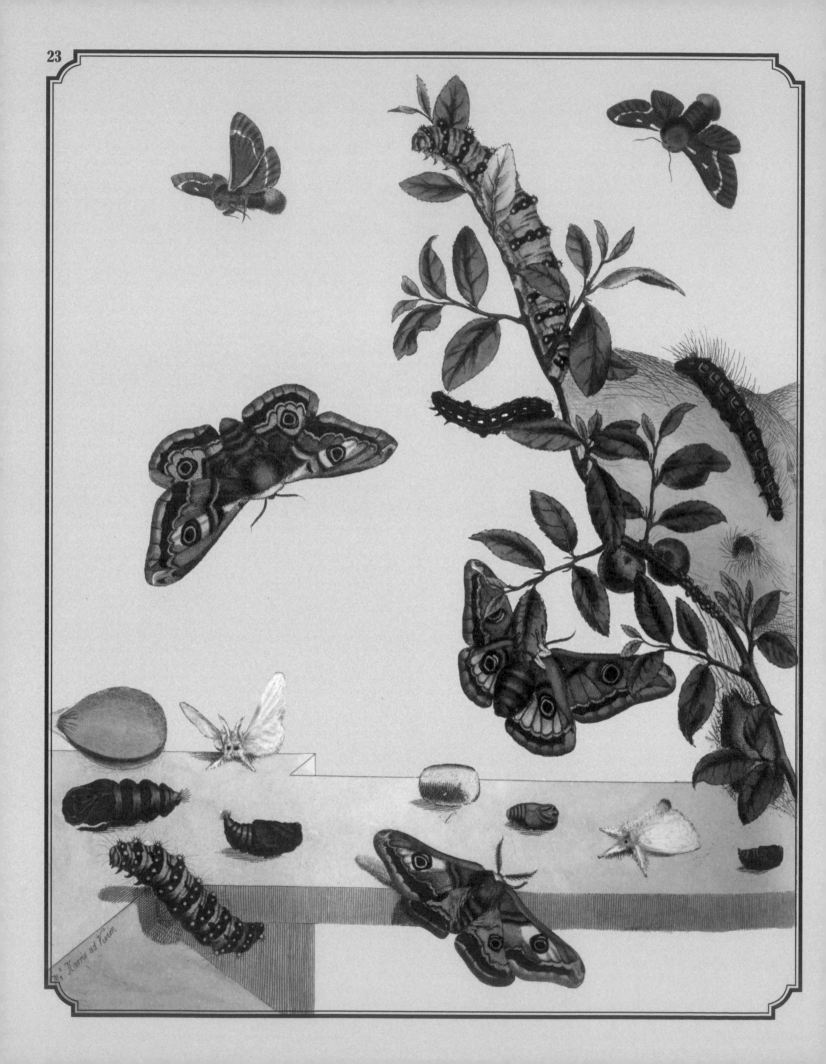

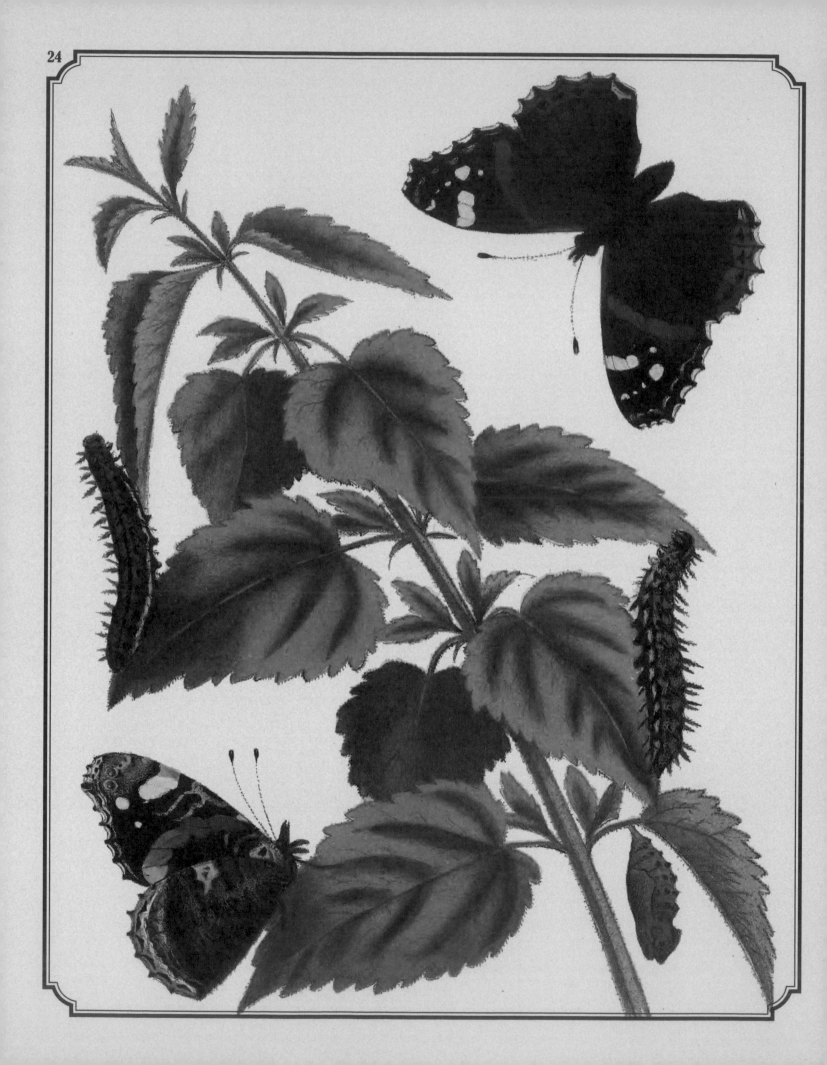

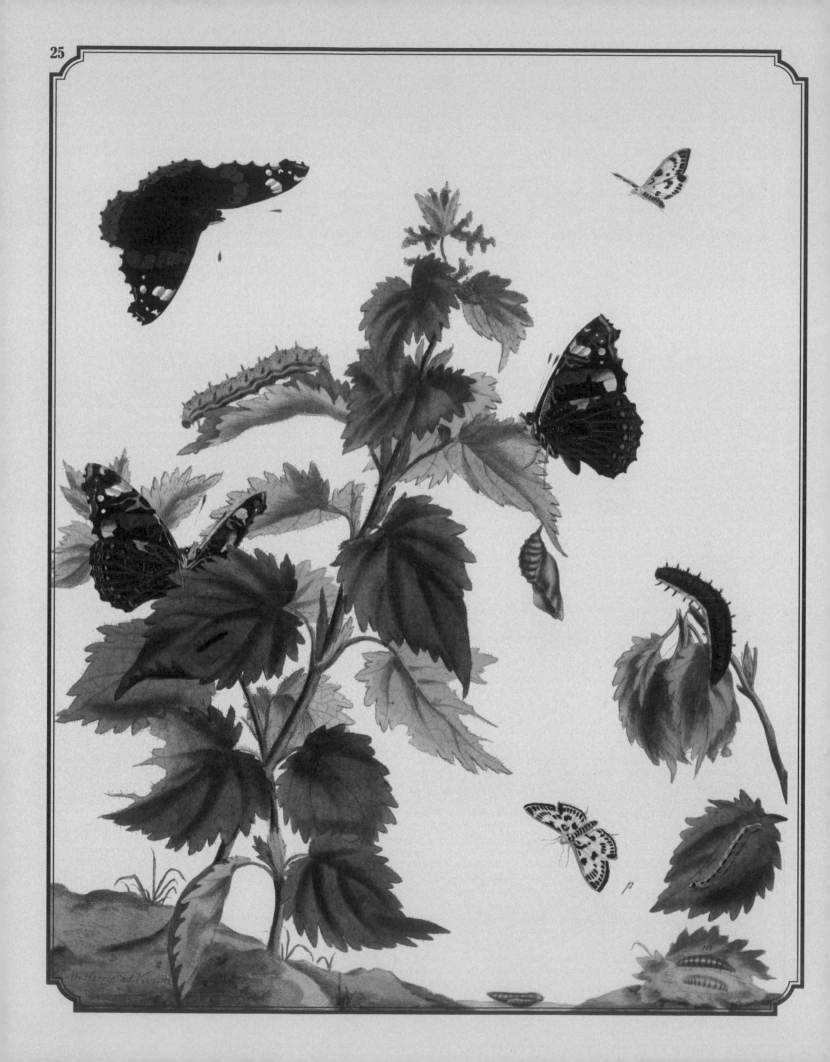

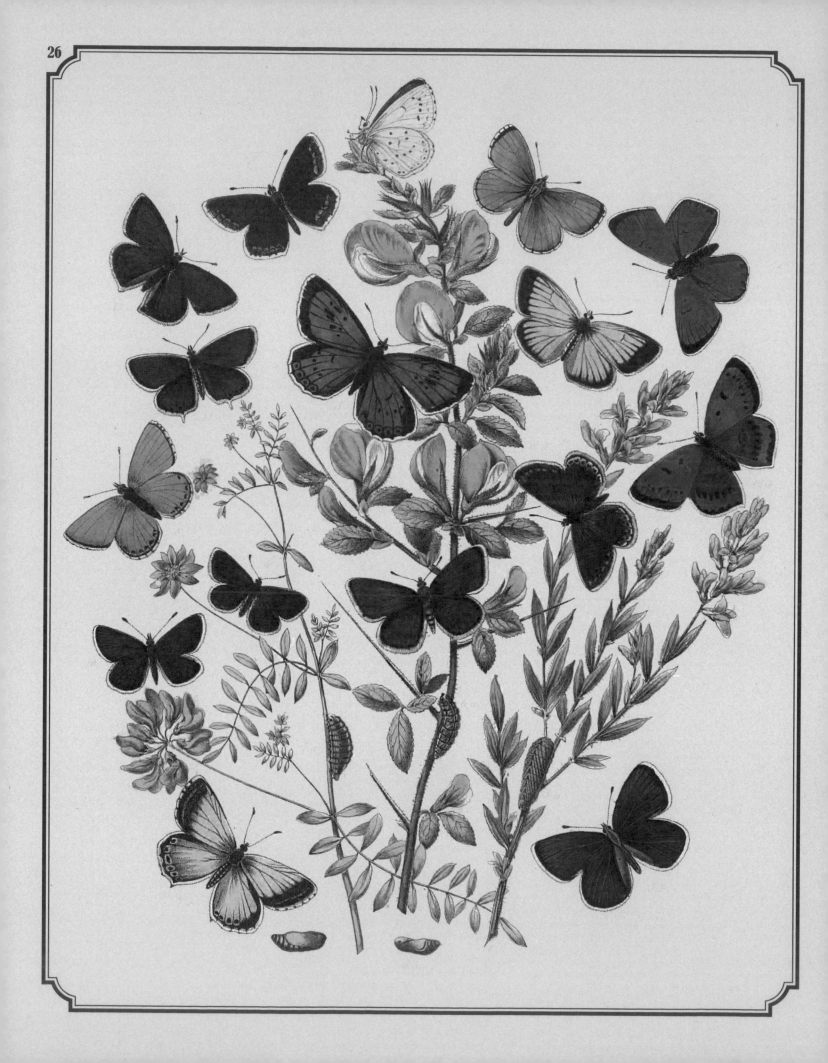

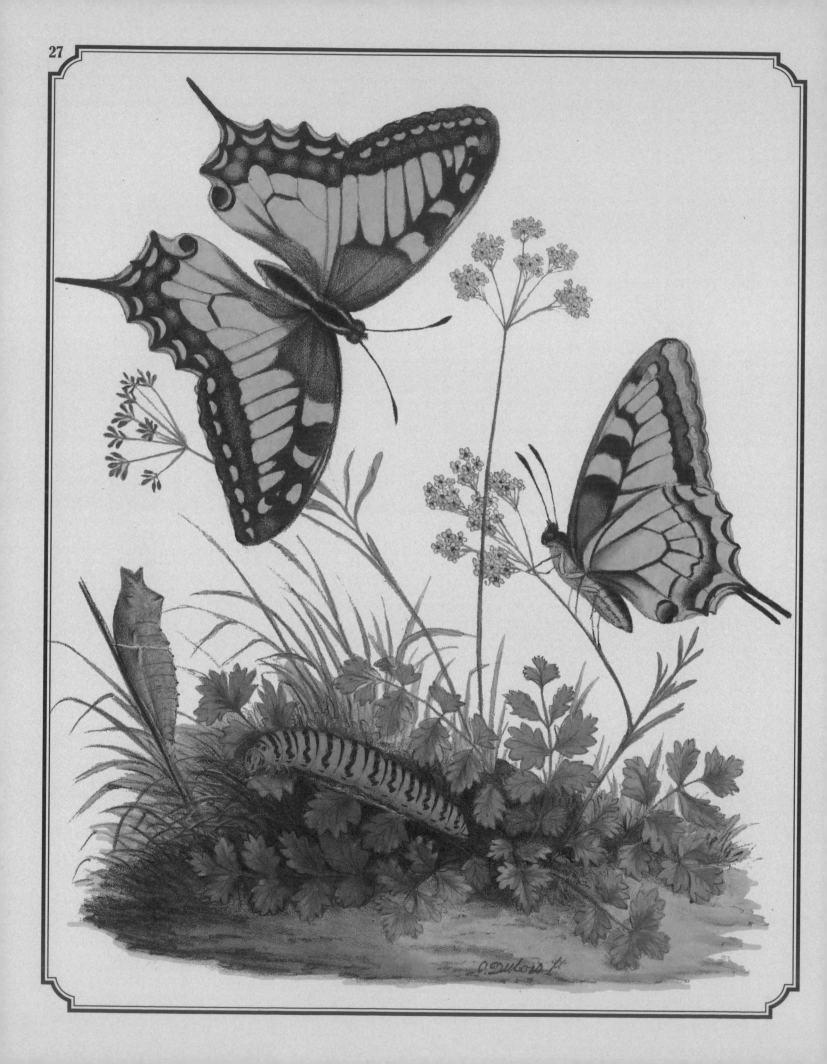

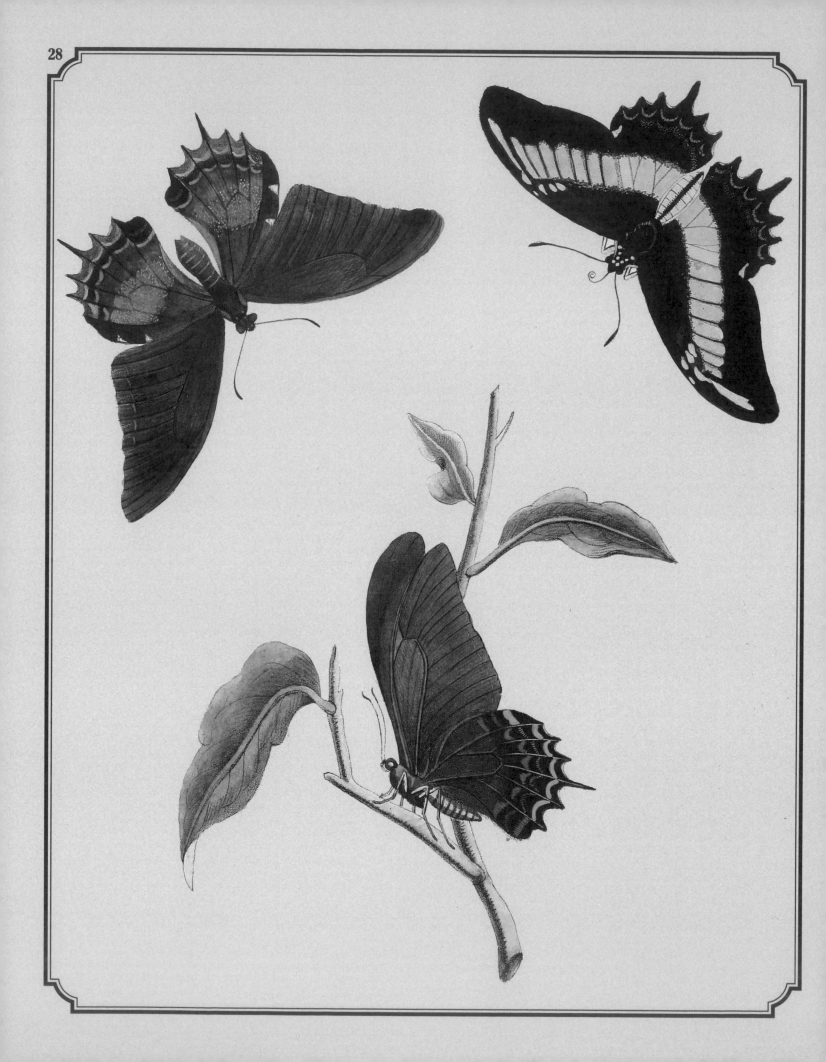

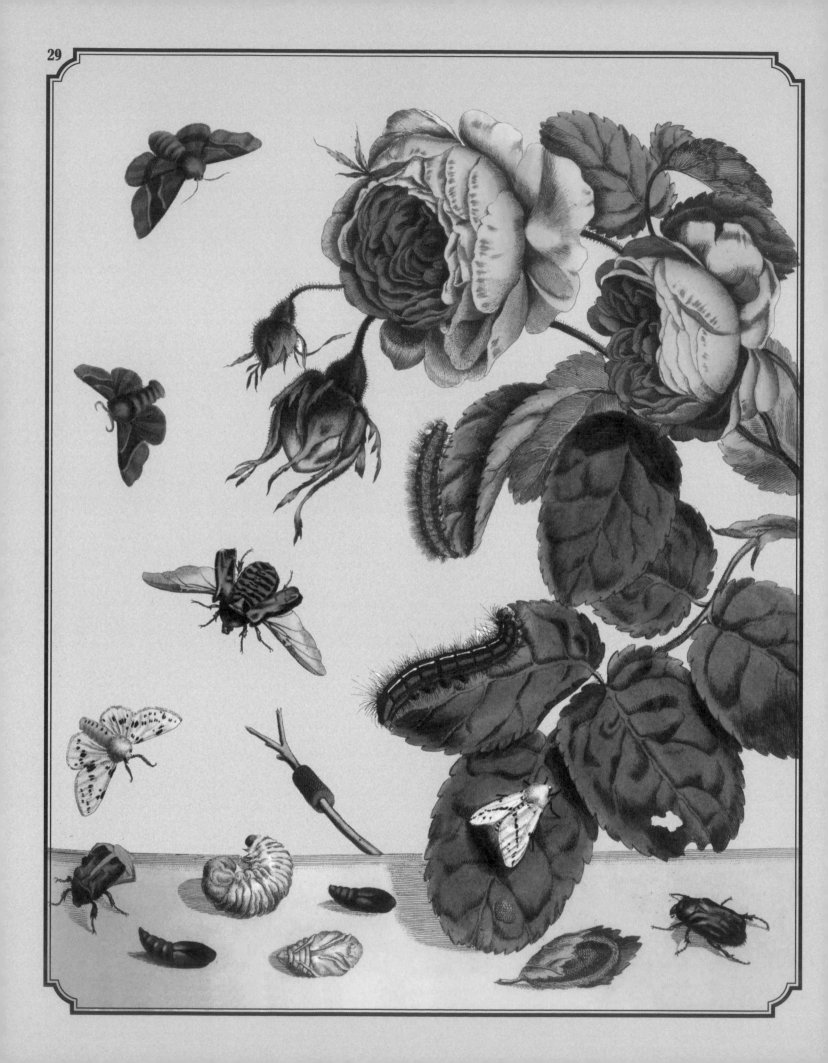

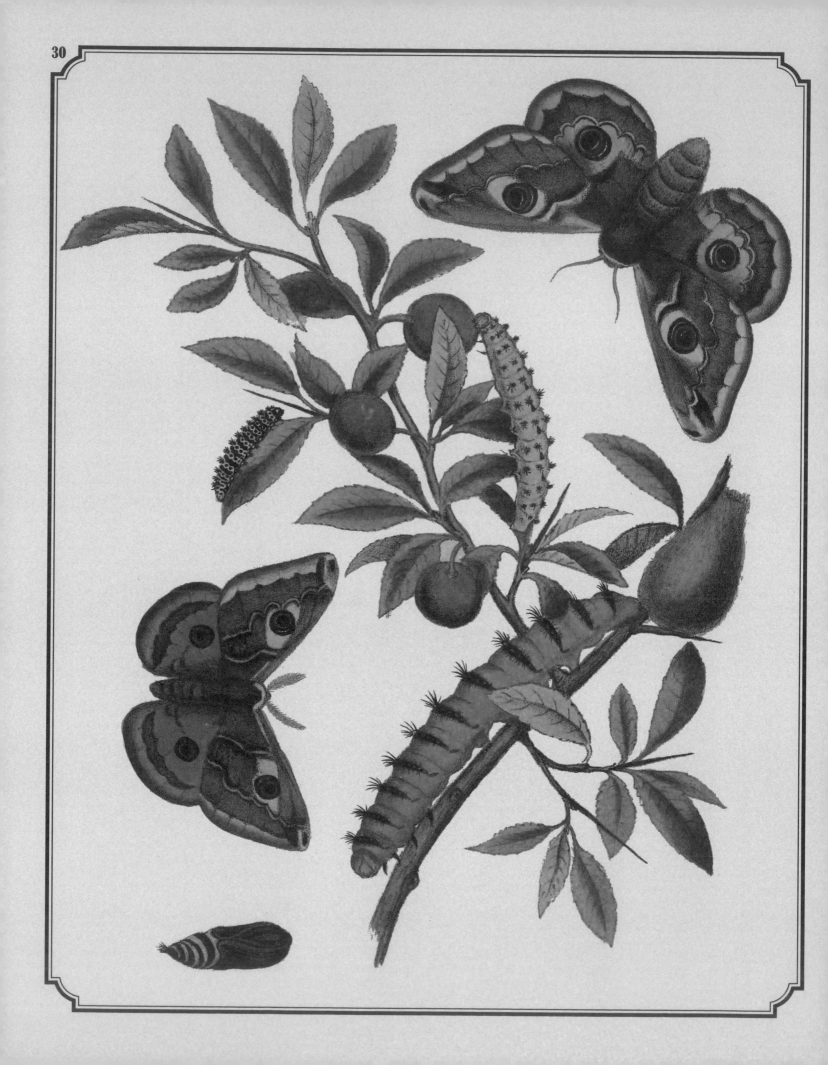

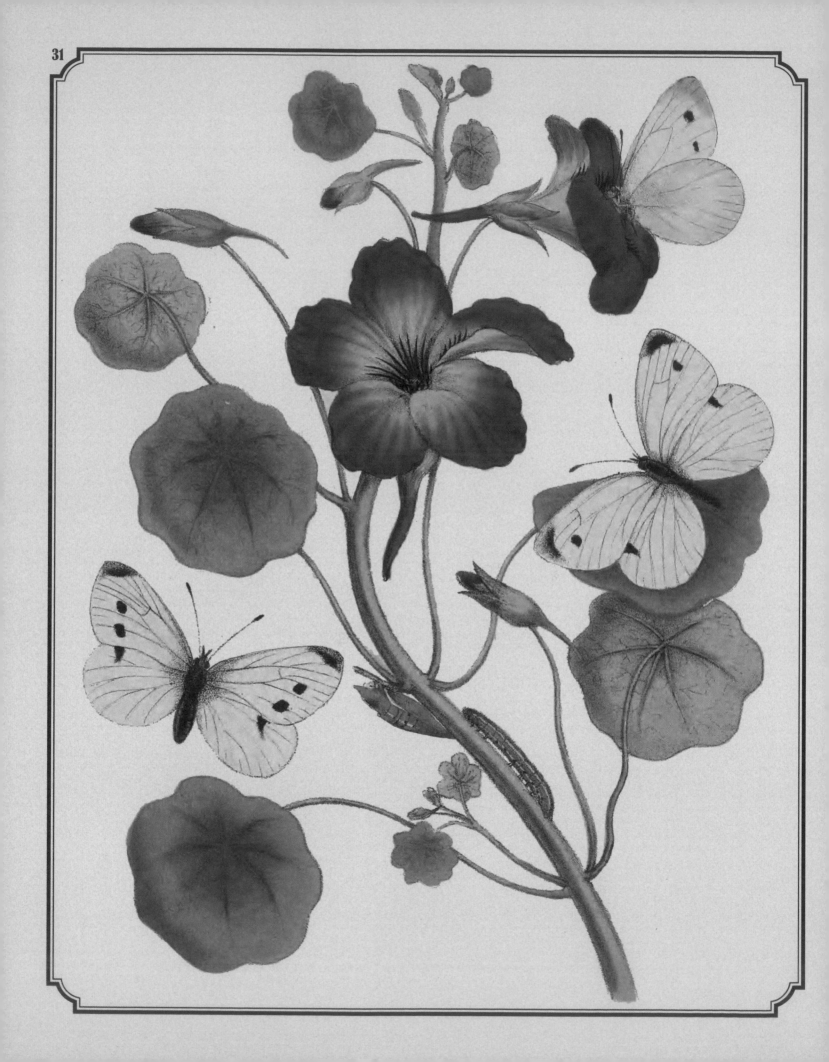

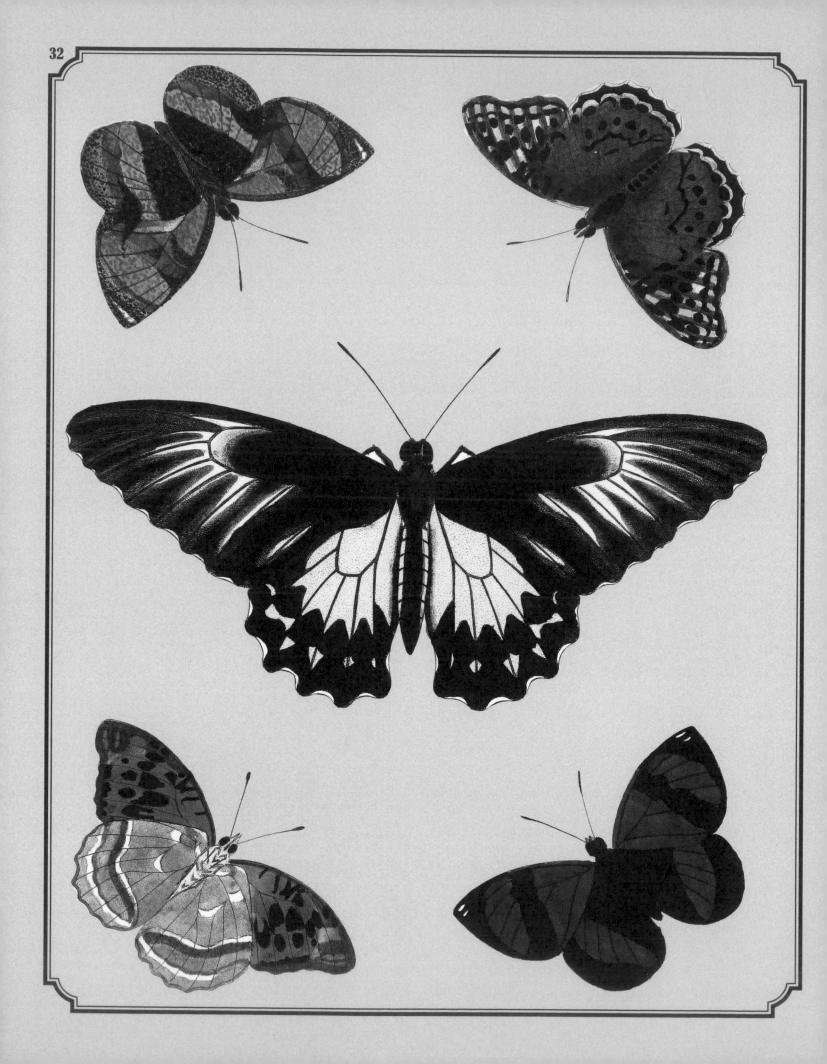

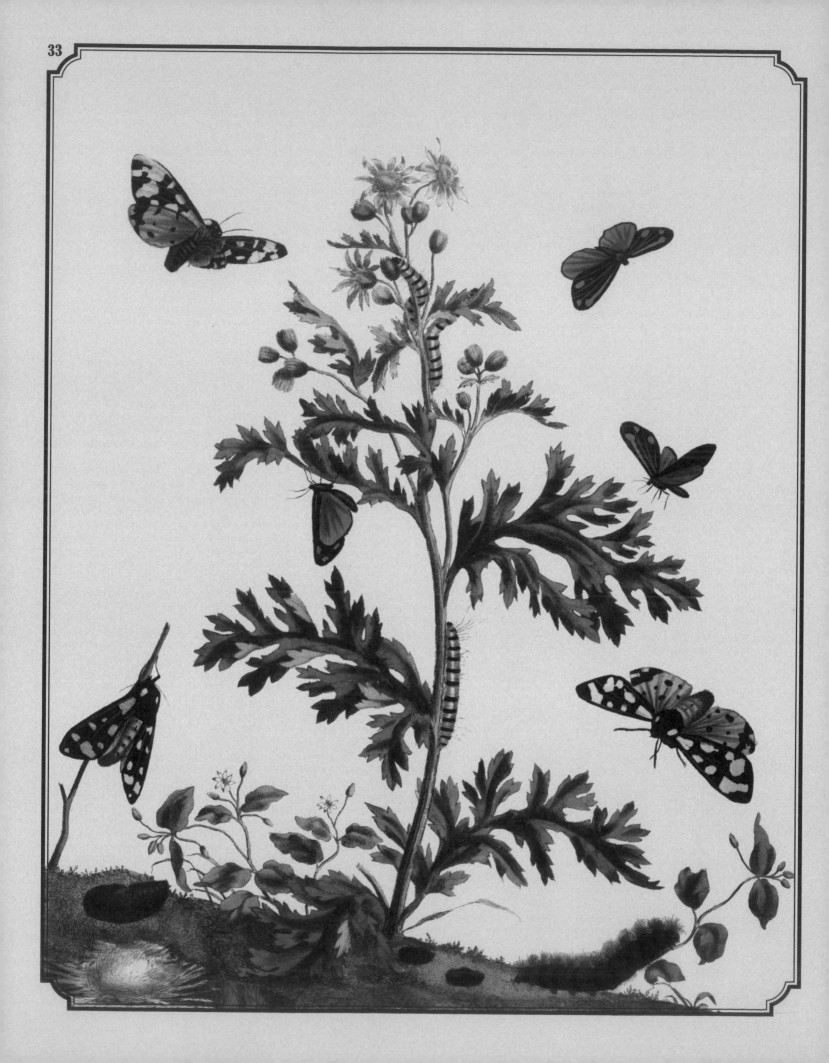

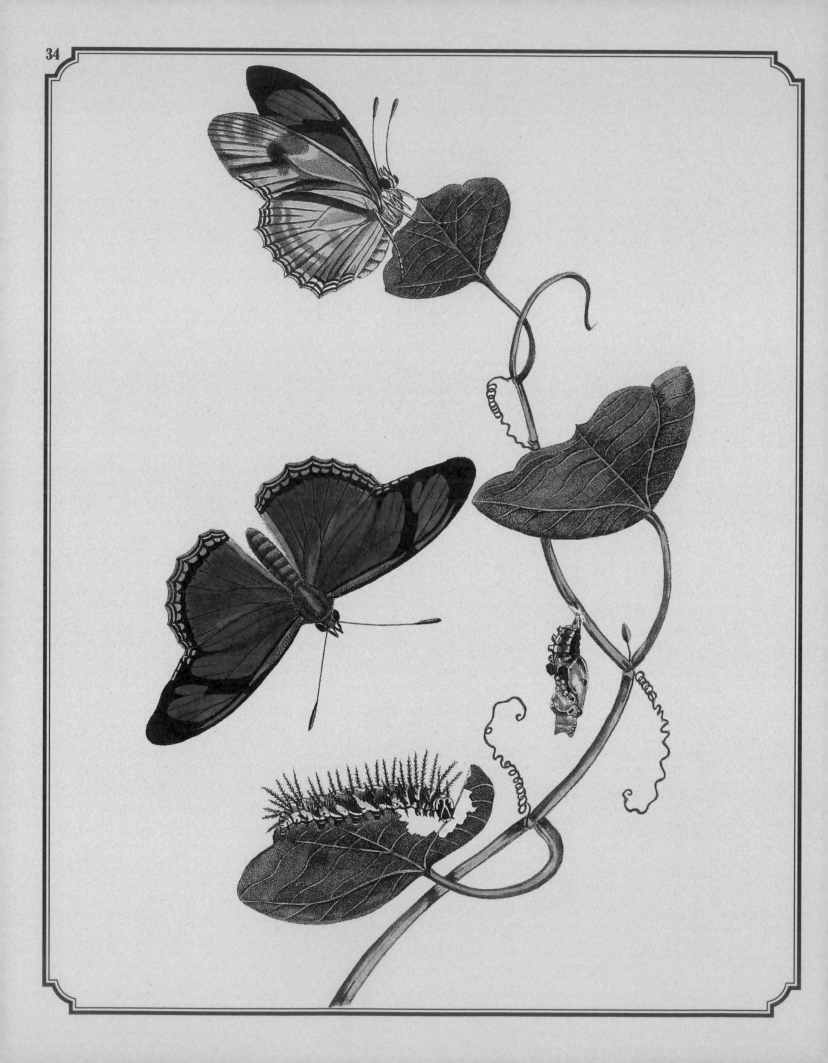

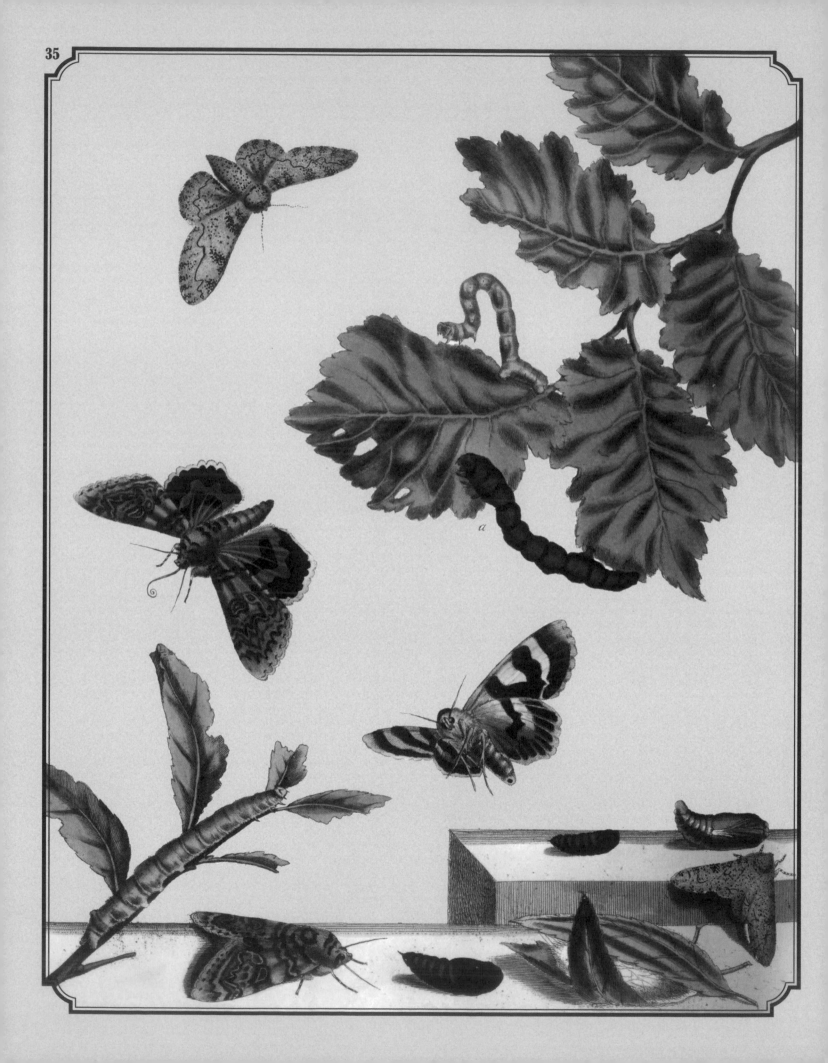

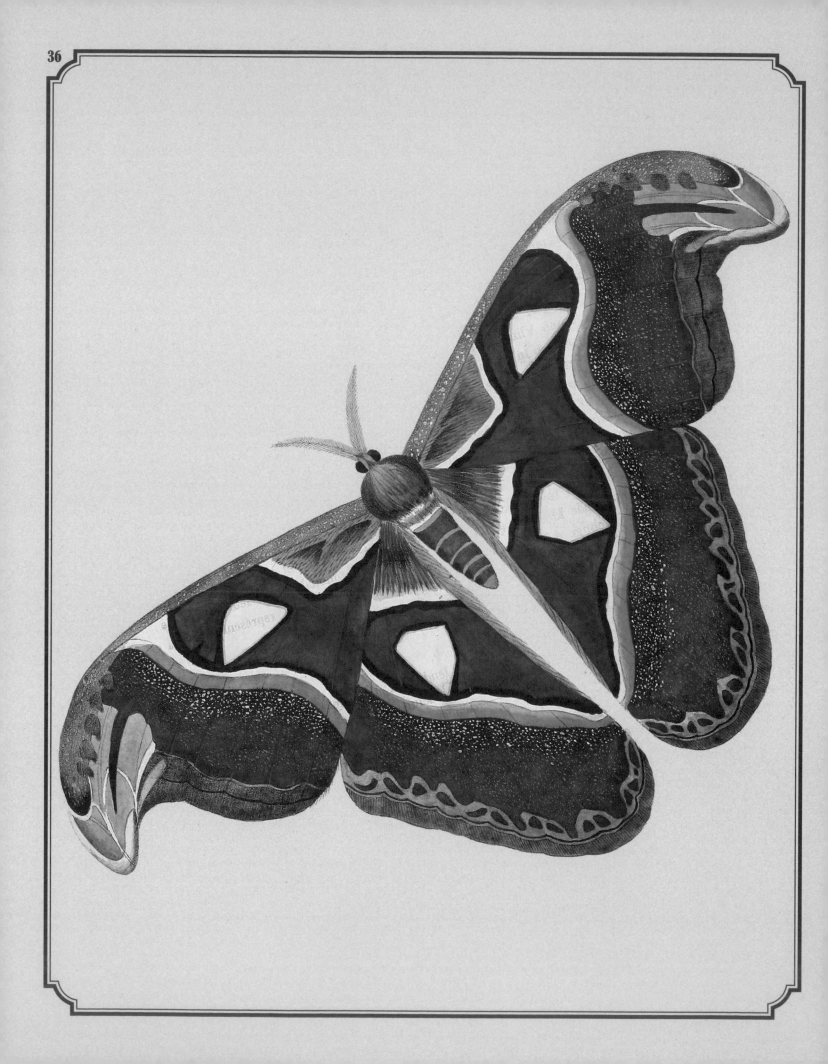

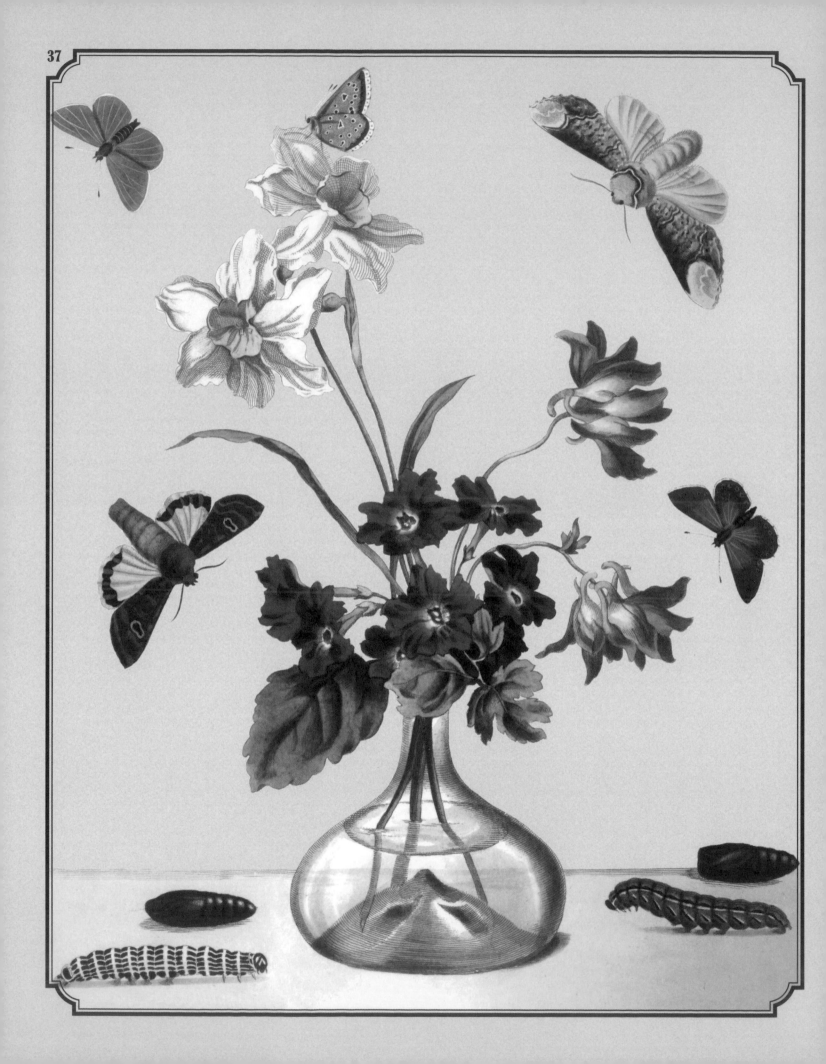

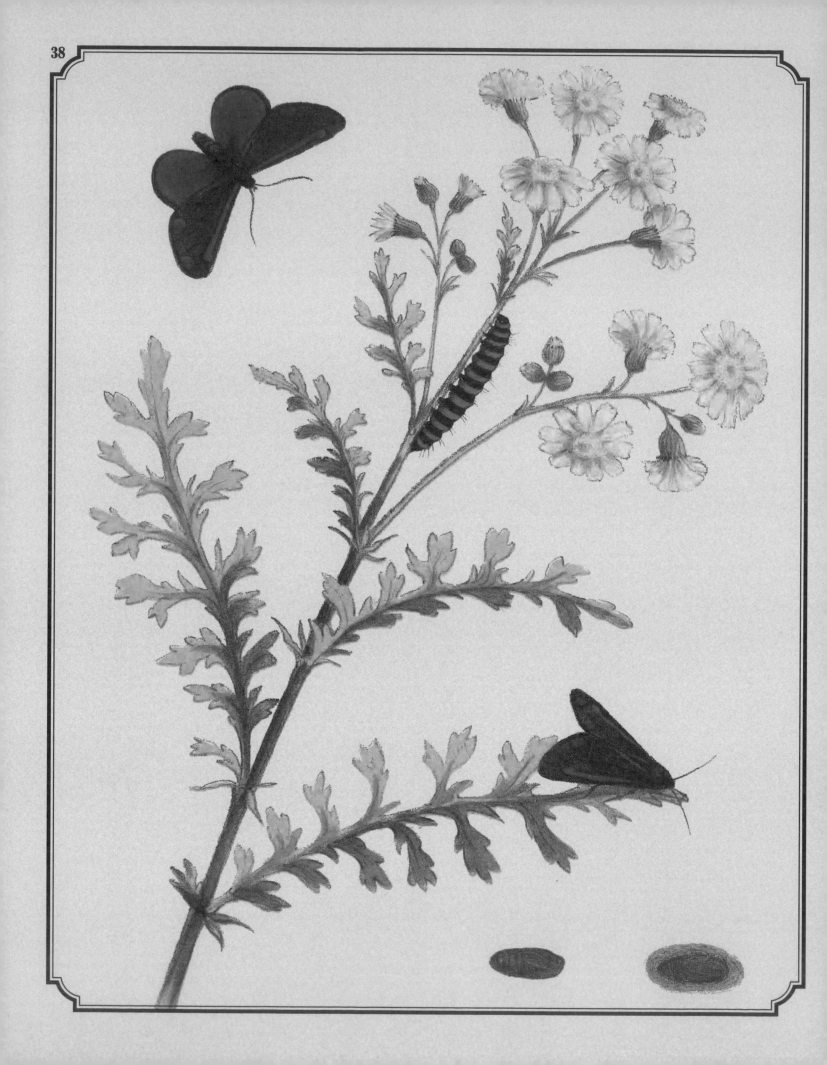

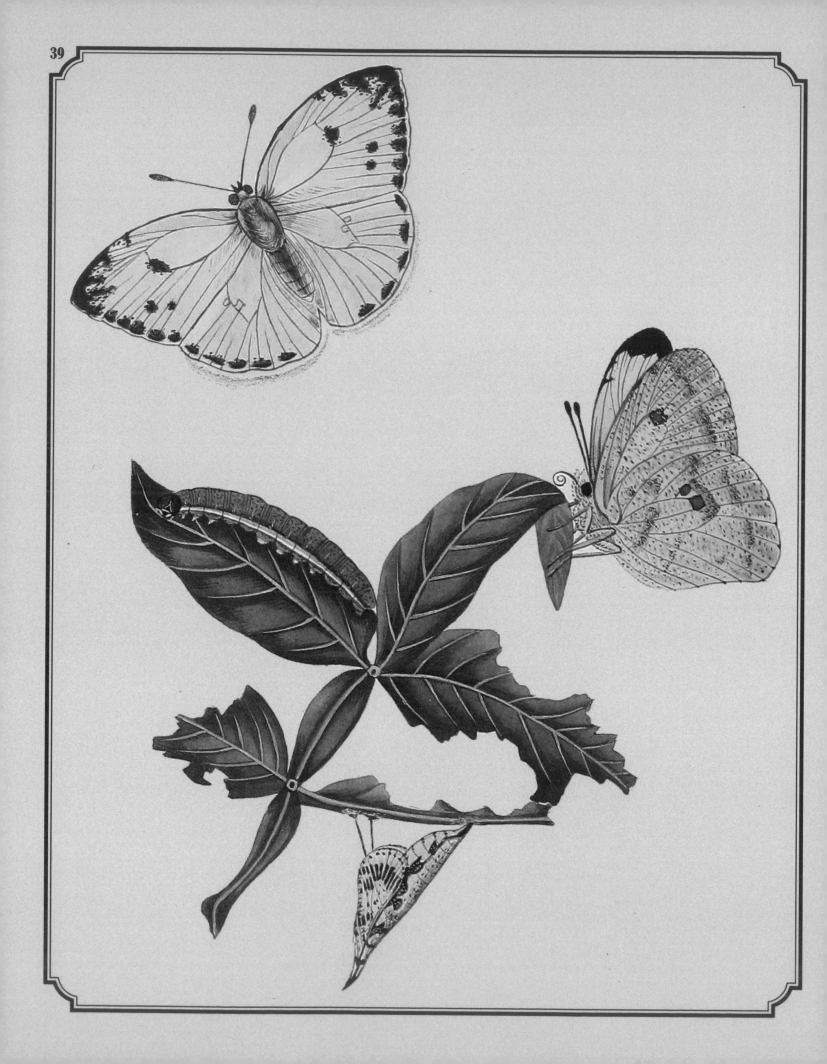

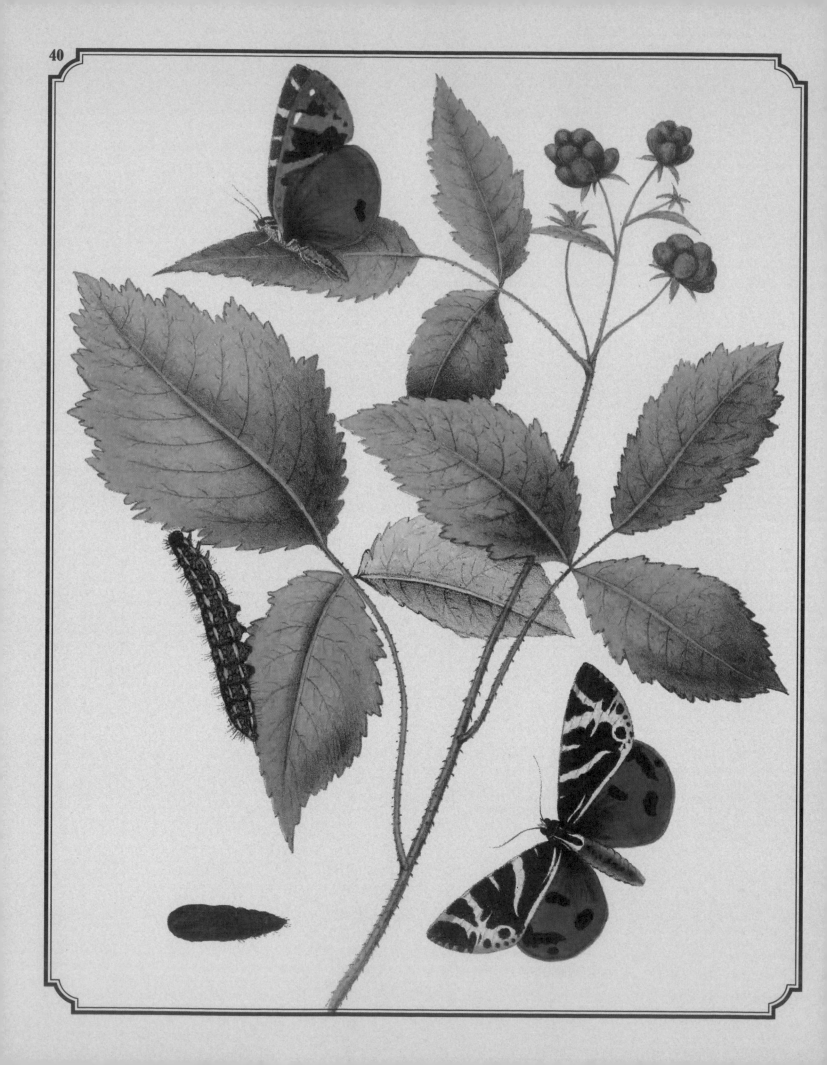

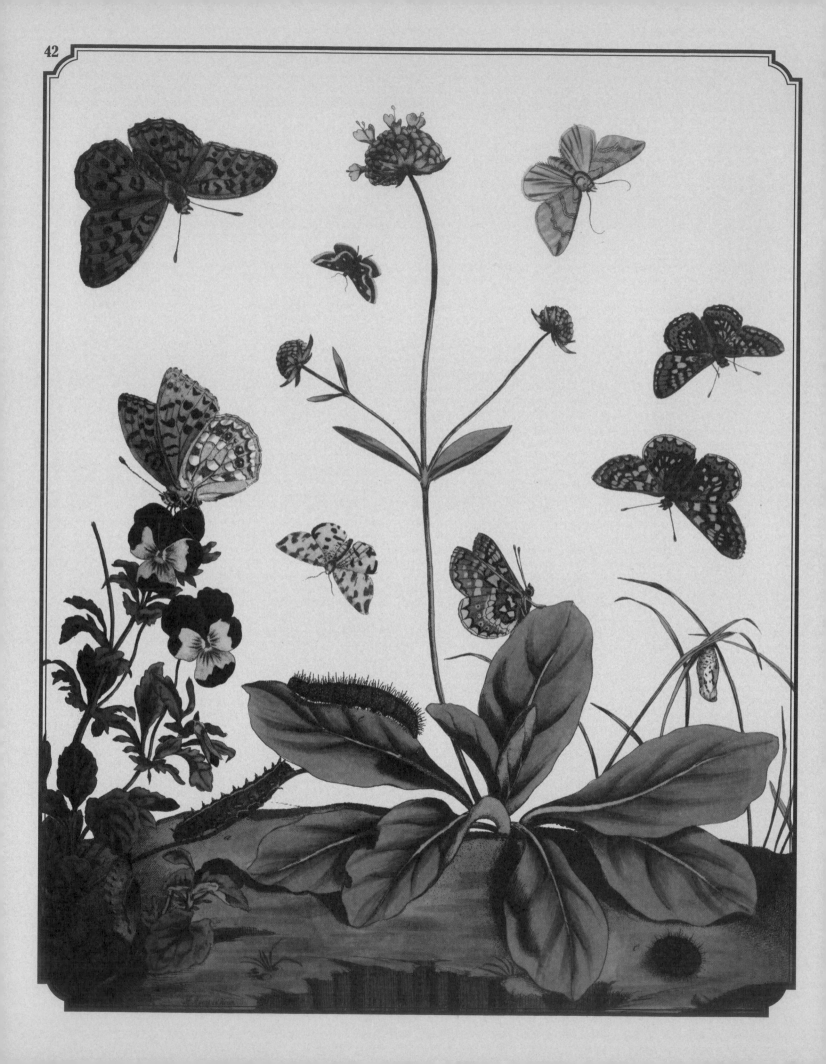

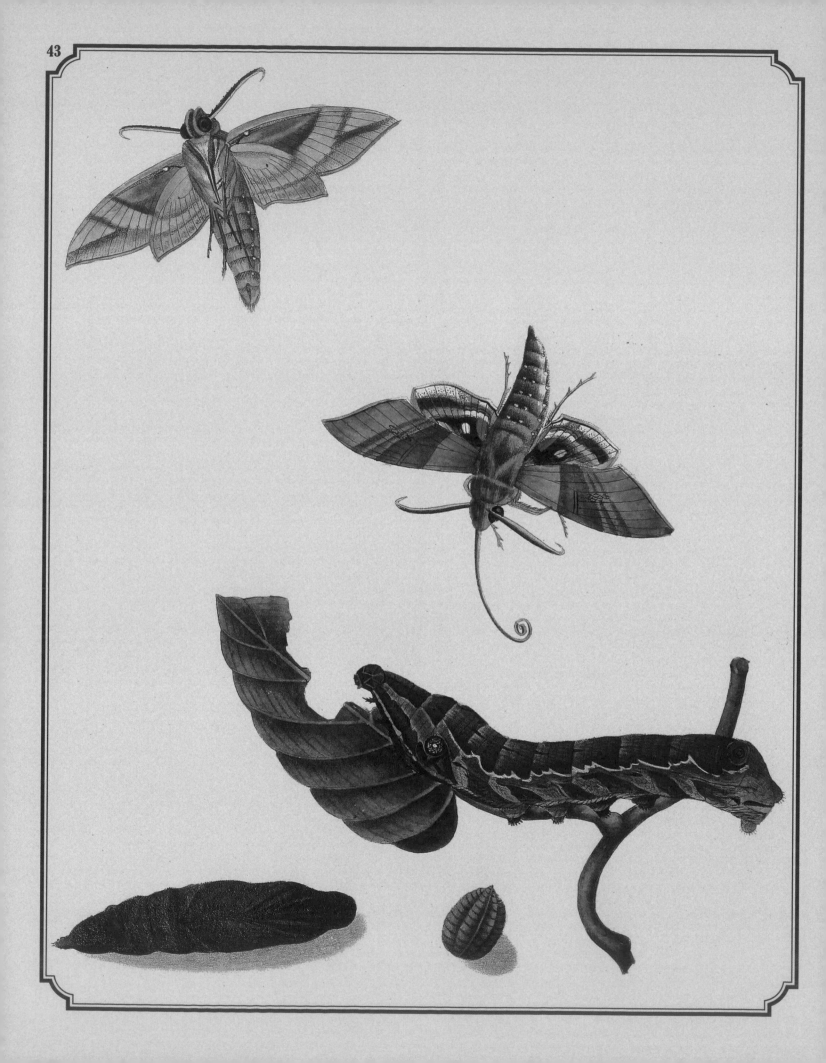

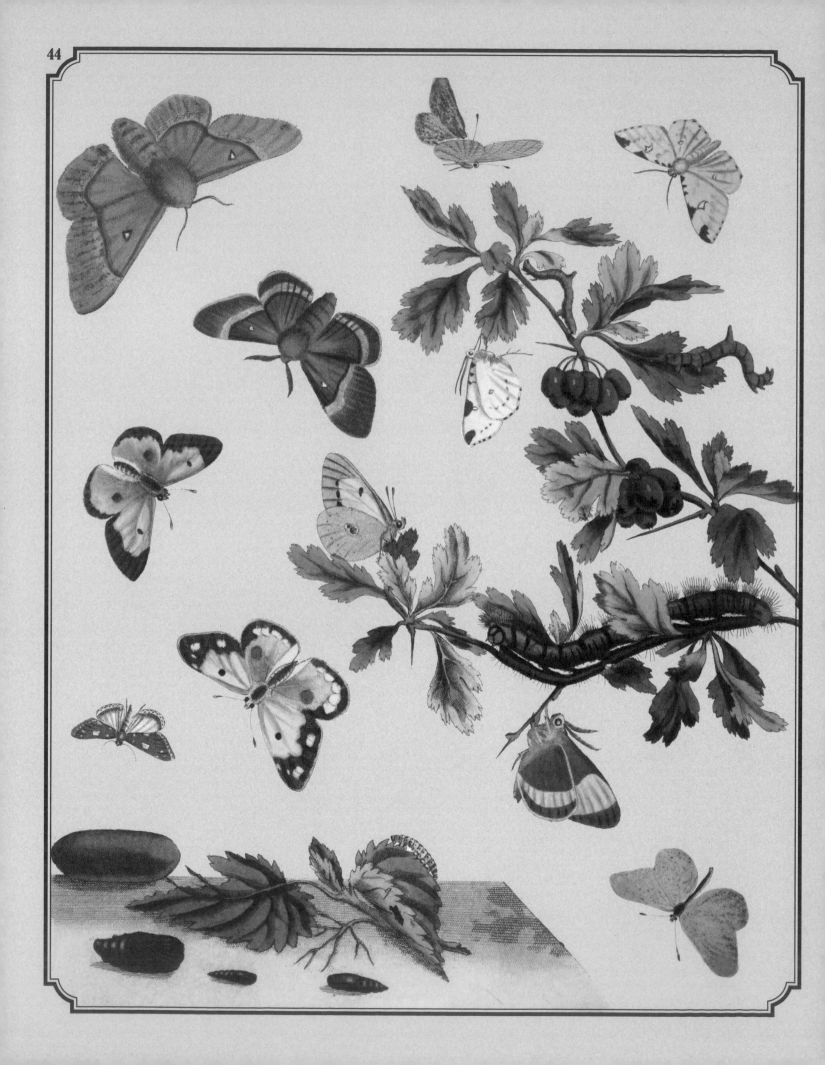

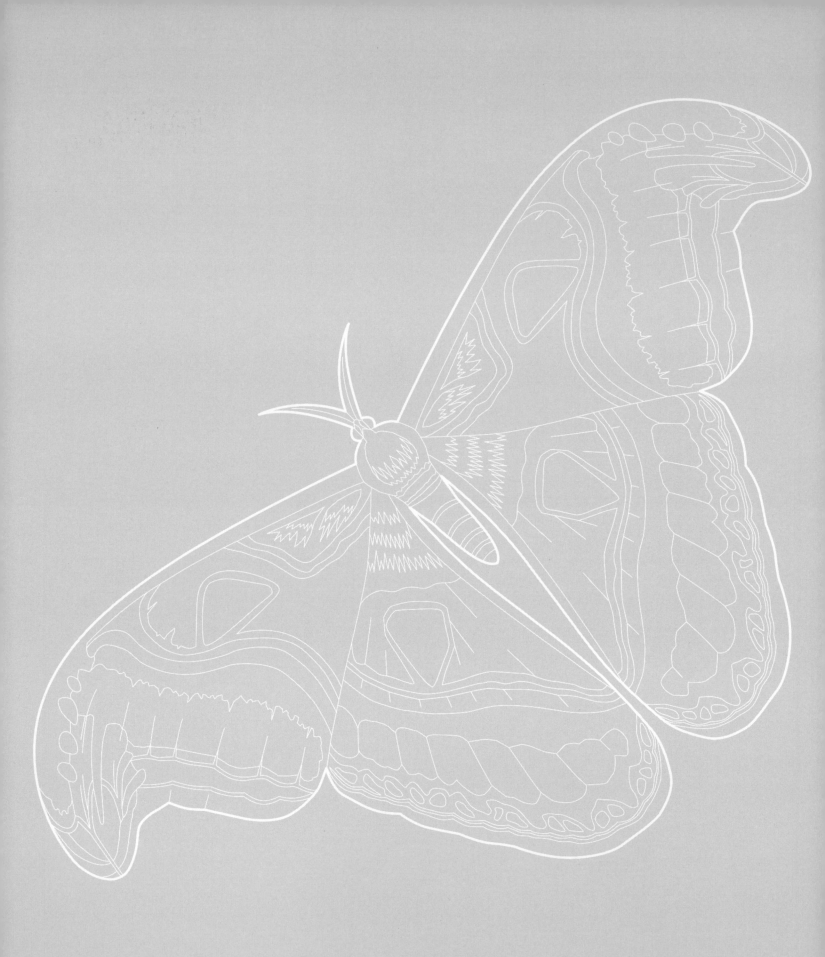